LITTLEHA LIFEBO

AN ILLUSTRATED HISTORY

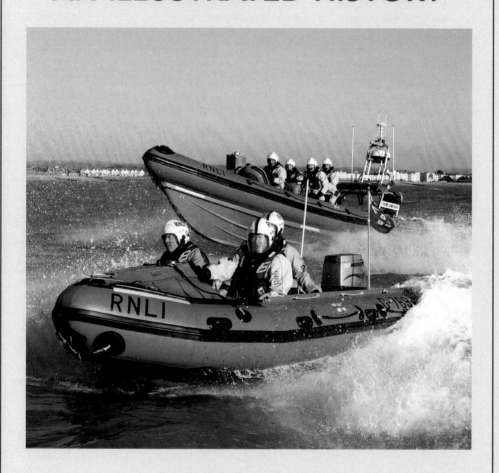

Nicholas Leach

FOXGLOVE PUBLISHING

First published 2017

Published by
Foxglove Publishing Ltd
Foxglove House, Shute Hill,
Lichfield WS13 8DB
United Kingdom
Tel 07940 905046

ISBN 9781909540095

Layout by Nicholas Leach/Foxglove Publishing

Printed in Great Britain

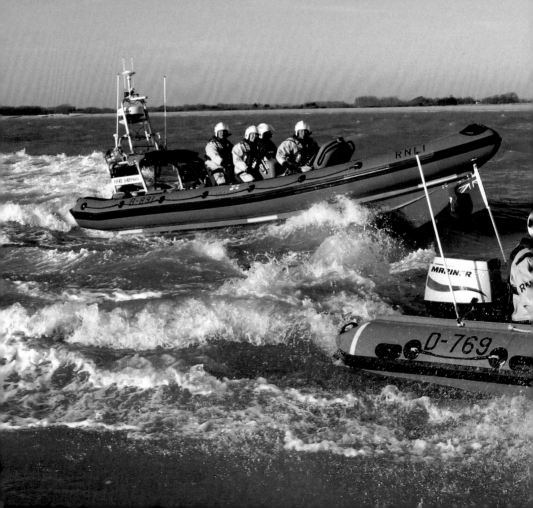

LITTLEHAMPTON LIFEBOATS

Contents

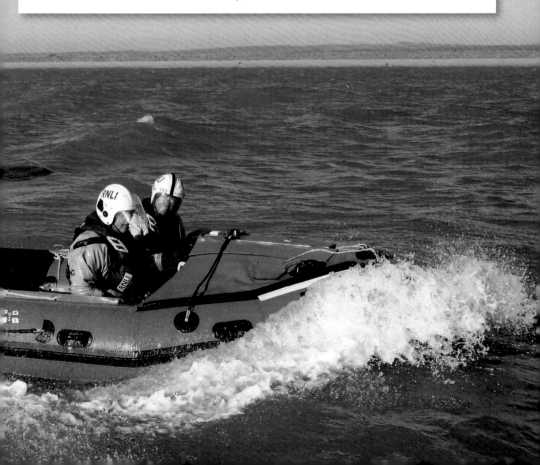

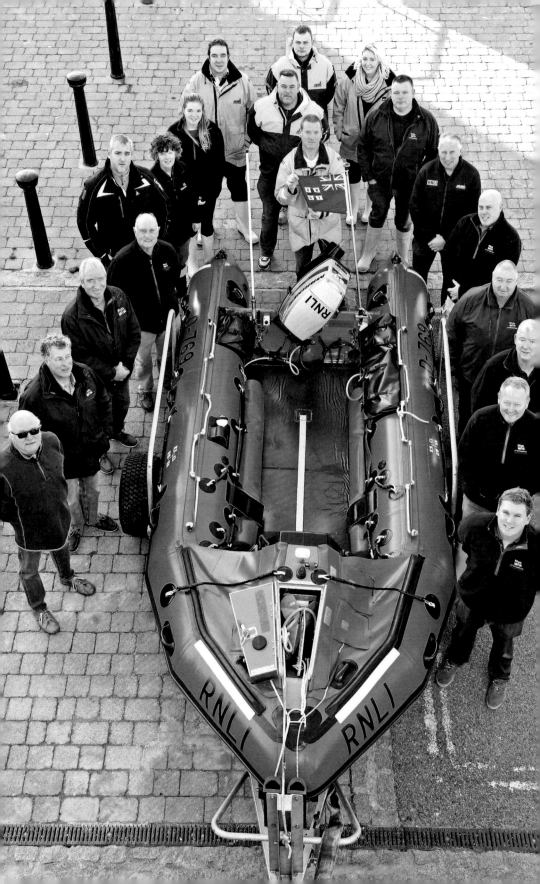

Foreword

The maroons were once fired, but now the bleepers sound. The rush to the boathouse and the sense of anticipation - am I on the 'shout,' what is it, and who needs help? The mind sharpens quickly as you rush to the boathouse. Start port, start starboard, engines purring, and all on board. Full astern, stop both, hard to port and full ahead. Casualty position in the system, radios and intercoms working, and course set. Chat to the team - 'this is what we are going to do' – and eventually we get there. The casualty has their hand aloft, an expectant look of incredible relief - the sight of the lifeboat suddenly steaming into view and the emotion of being rescued from the peril of the sea is all consuming to everyone involved - and one of the most satisfying acts of kindness and courage that all lifeboat men and women understand.

Today, the best lifeboats and equipment are provided for our crew and shore helpers, and always with support from families and partners. From local fund-raising in support of the RNLI to Sunday and Thursday nights spent training together in most weather; these are my recollections from having been on the crew some decades ago. Courage, commitment and integrity are just some of the values of being in the RNLI family.

In this book, which marks the Littlehampton station's fiftieth year, you very quickly get a sense of the many outstanding individuals who have supported both the station and the RNLI in a raft of different roles over the years. As the Chairman of the Littlehampton station, I am very proud to be involved with the lifeboat and am constantly impressed with the dedication of all who support it:, either getting the boat to sea or raising funds to support it. This book is about our yesterdays as well as today, and every person associated with the station, whether ashore or at sea, has ensured that the Littlehampton lifeboat has always been there to rescue those in peril on the sea.

Mike McCartain OBE, Chairman, Littlehampton Lifeboat Management Group

"We make a living by what we get, but we make a life by what we give" – Winston Churchill

◀ Littlehampton lifeboat crew, December 2016, left to right, bottom to top: Ray Pye (lifeboat press officer), Nick White (LOM), David Gates (DLA), Geoff Warminger (boathouse manager), Adam Harding (shore crew), Min Morgan (shore crew), Alice White (shore crew), Matt Brewster (shore crew), Richard Howlett (trainee crew), Adam Grummett (at back, trainee crew), Ritchie Southerton (holding ensign, crew), Hannah Presgrave (trainee crew), Steve Howlett (trainee crew), Andy Harris (crew), Warren Marden (crew), Ivan Greer (crew), Jim Cosgrove (crew), Ian Foden (crew) and Liam Clarke (crew). (Nicholas Leach)

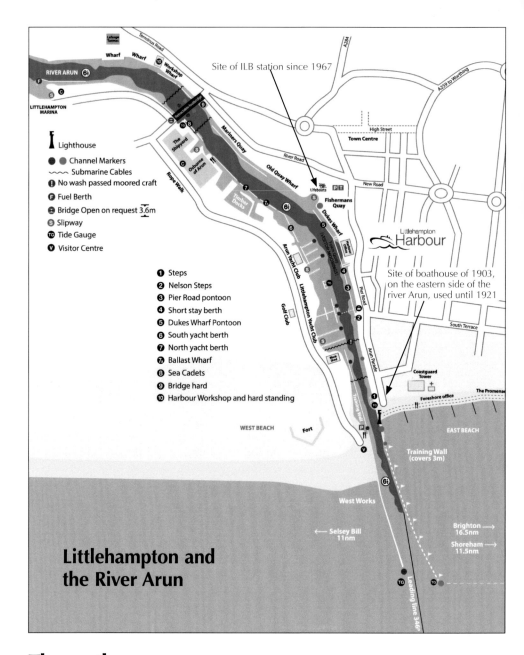

Littlehampton and
the River Arun

Map legend:

- Lighthouse
- ● ● Channel Markers
- ~~~ Submarine Cables
- No wash passed moored craft
- Fuel Berth
- Bridge Open on request 3.6m
- Slipway
- Tide Gauge
- Visitor Centre

1 Steps
2 Nelson Steps
3 Pier Road pontoon
4 Short stay berth
5 Dukes Wharf Pontoon
6 South yacht berth
7 North yacht berth
7a Ballast Wharf
8 Sea Cadets
9 Bridge hard
10 Harbour Workshop and hard standing

Site of ILB station since 1967

Site of boathouse of 1903, on the eastern side of the river Arun, used until 1921

The author

Nicholas Leach has a long-standing interest in lifeboats and the lifeboat service. He has written many articles, books and papers on the subject, including a history of the origins of the lifeboat service; a comprehensive record of the RNLI's lifeboat stations in 1999, the organisation's 175th anniversary; RNLI Motor Lifeboats, a detailed history of the development of powered lifeboats; and numerous station histories, including ones covering Padstow, Humber, Holyhead, Moelfre and Longhope. He has visited all of the lifeboat stations in the UK and Ireland, past and present, and is Editor of Ships Monthly, the international shipping magazine.

Introduction

Littlehampton lifeboat station is one in the chain of more than 230 operated by the Royal National Lifeboat Institution (RNLI) around the coasts of the United Kingdom and Ireland. The station was first opened in the late nineteenth century, but was closed after the First World War when the transition to motor lifeboats saw the number of stations being reduced. However, it was reopened in the 1960s with an inshore lifeboat (ILB), and has since gone from strength to strength.

The ILB has been refined, enlarged and developed since the 1960s so that today it is a sophisticated rescue tool and is seen as the workhorse of the RNLI's fleet. The Littlehampton station itself became particularly well known as home to one of the Blue Peter-funded lifeboats, and Blue Peter inshore lifeboats served the station for forty-nine years until 2016. Numerous Blue Peter presenters have been to the station, which in turn has been featured on national television on many occasions.

Littlehampton is today a busy yacht harbour, but was at one time a ship and boatbuilding centre. In the nineteenth century Stephen Olliver, the Isemonger brothers and Henry Harvey all operated from small repair yards. Harvey's Shipyards on the west bank of the Arun, one of the most prominent in Littlehampton's shipbuilding history, constructed ocean-going vessels of 500-600

Seen from the sea, the entrance to Littlehampton harbour, where the River Arun meets the sea, with the small lighthouse on the east side of the river. (Nicholas Leach)

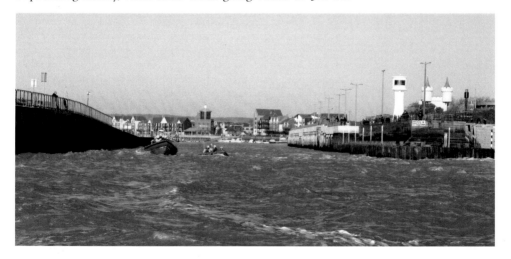

tonnes which sailed all over the world. The Robinsons, Peppers and Isemongers, and later William Osborne and luxury yacht makers Hillyards, were all integral in building the town's reputation as the home of shipbuilding. Indeed, Osborne was involved in lifeboat construction for many years, and one of the RNLI's most successful designs of lifeboat was named after the River Arun, as the prototypes were built on its banks, so this book also includes a history of lifeboat building in Littlehampton. *Nicholas Leach*

Acknowledgements

Many people have assisted with this project to produce a comprehensive history of the Littlehampton lifeboats, and the author and Littlehampton RNLI are grateful to those who contributed. For supplying images, we would like to thank Iain Boothby, John Crockford-Hawley, Susan Cheney, James Clevett, Tony Denton, Grahame Farr, Ian Foden, John Harrop, David Humphries, Andy T. Lee, Eddie Mitchell, Ritchie Southerton, Iain Tebb, Geoff Warminger, John White, David Woollven, and Nathan Williams at the RNLI's Film and Imaging Unit; photographs have been credited where possible, but in some cases the same image has been supplied by two sources. Many former and current crew and lifeboat station volunteers have offered information and recollections. Particular thanks goes to those with the longest memories: Robert Boyce, Susan Cheney, Ray Lee, Mike McCartain, John Pelham, Geoff Warminger and David Woollven. We are also very grateful to author Nicholas Leach, a lifeboat expert and enthusiast, who would like to thank Hayley Whiting of the RNLI's Heritage Trust for providing research facilities. Finally, Littlehampton Rotary Club has underwritten the costs of the book, and our thanks go to Mike Findlay and David Humphries, and to Roger Aspinwall who initiated Rotary involvement with the station, but who sadly passed away before the project was completed.

Nick White, Lifeboat Operations Manager, February 2017

Below left: An aerial view of the harbour entrance from the 1960s. Navigating in and around Littlehampton harbour can be challenging, with the approaches drying out at low water, while in even moderate onshore weather the entrance can be very rough. (By courtesy of the RNLI)

Below right: Fisherman's Quay as it was in 2016, with the lifebat house, slipway into the river and new residential housing built around the area. The site has been home to Littlehampton lifeboat station since 1967, and several boathoses have been built for the successive generations of inshore lifeboats. (Nicholas Leach)

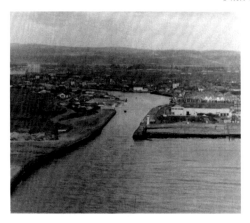

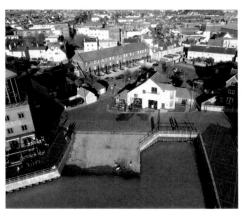

The Pulling Lifeboats

T he lifeboat station at Littlehampton was established in 1884 at a time when the Royal National Lifeboat Institution (RNLI) was operating the largest number of lifeboats at any time in its history. The second half of the nineteenth century was the heyday of the 'standard' self-righting lifeboat, which had been perfected since its conception in 1851 so that by the 1880s it was almost the only type of lifeboat in use, and the three pulling lifeboats that served Littlehampton throughout its thirty-seven years of pulling lifeboat operations were all self-righters. The self-righter was primarily a rowing boat, only 34ft or 35ft in length, and its radius of action was rather limited. For this reason, the stations that operated them were often in close proximity to one another.

The national lifeboat organisation that became the RNLI was founded on 4 March 1824 by Sir William Hillary, of Douglas in the Isle of Man, as the Royal National Institution for the Preservation of Life from Shipwreck (RNIPLS). Hillary's aim was to organise a national lifeboat service, but this took many years to fully implement and not until the 1850s, when sufficient finance was being raised, did a national lifeboat service become a reality. The coastline around Littlehampton was covered, until the 1860s, by independently financed and operated lifeboats, with Newhaven, Brighton and Shoreham all having rescue boats of some form before the national institution took over. During the 1850s the RNIPLS was reformed and renamed Royal National Lifeboat Institution, and thenceforth, during the second half of the nineteenth century, it properly fulfilled the aims of its founder and provided a truly nationwide lifeboat service.

The 1860s and 1870s were a time of great expansion in lifeboat provision, and by the time the station at Littlehampton had been opened in 1884, the Sussex coastline was reasonably well covered, with the RNLI operating stations at Eastbourne (taken over in 1853), Brighton (taken over in 1858), Selsey (opened 1861), Hayling Island (opened 1865), Worthing (taken over in 1865), Shoreham Harbour (taken over in 1865) and Chichester Harbour (opened 1867). In 1886 a lifeboat was sent to Southsea to cover Portsmouth

KEY DATES

1884 Station opened by the RNLI with a pulling lifeboat

1903 New lifeboat house built

1921 Station closed and lifeboat withdrawn

1967 Station reopened by the RNLI with ILB

1972 First Atlantic 21 placed on station

1979 New ILB house built

2002 Second ILB placed on station and new ILB house completed

2016 Blue Peter funded lifeboat left the station

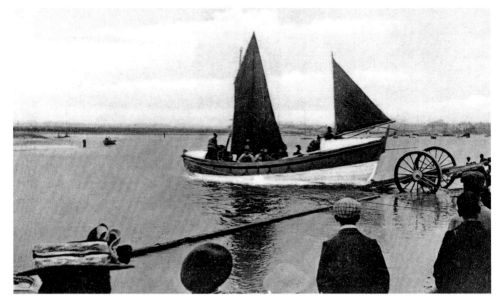

With her sails ready, Undaunted is launched from her carriage into the River Arun. (From an old postcard supplied by Iain Boothby)

harbour. Between 1853 and 1886 no fewer than ten new stations in Sussex and Hampshire were established or taken over by the RNLI, and all were supplied with self-righting lifeboats.

Before the lifeboat stations had been founded, rescues were undertaken by locals using boats that happened to be available in the vicinity of a shipwreck. The National Institution rewarded those who helped to save life at sea, recognising bravery with the awarding of Gold and Silver medals for acts of outstanding courage, whether performed in an RNLI lifeboat, a shore boat, or even from the shore itself. One such award was made after the brig *Victoria*, of Sunderland, had been driven ashore near Littlehampton during an extremely violent storm on 13 November 1840. She had a crew of nine and they drifted a line ashore, by means of which Lt Timothy Macnamara, of the local Coastguard, and his men, assisted by Lt George Davies and his team of Coastguards, hauled a small boat out to the wreck three times and saved the whole crew.

Shortly afterwards, the sloop *Lively*, of Poole, was also driven ashore. Macnamara and his men were soon on scene to help again and, in spite of huge waves crashing onto the beach, waded into the sea with lines tied around them. At great personal risk, they managed to save all five men from the sloop. For his outstanding bravery, Macnamara was awarded a Gold medal by the RNLI, with Lt Davies receiving a Silver medal. Monetary awards were made to the other Coastguardsmen who had been involved in the rescues.

Undaunted

In 1884 the RNLI established a lifeboat station at Littlehampton, 'for the protection of the numerous sailing vessels trading there',

as *The Lifeboat* for August 1885 explained. In March 1883 District Inspector Captain Chetwynd had proposed to the Chichester Harbour and Selsey Branch that the Chichester Harbour lifeboat should be moved to Littlehampton. It was unanimously agreed that such a move would be beneficial and should be undertaken, with a sub-committee of the Chichester Branch formed at Littlehampton, similar to that at West Wittering.

The Chichester Harbour station, which had been established in 1867 near West Wittering, was intended to cover the entrance of Chichester harbour, to the west of Selsey. Two lifeboats served during the station's seventeen years of operations, and the last of these was moved to Littlehampton, which was to the east of Selsey. Only a handful of service launches had been carried out by the Chichester Harbour volunteer lifeboat crews, and no lives had been saved, so that by the 1880s the RNLI concluded that 'the station had ceased to be of use'. Finding a suitable site for a boathouse at West Wittering, as well as launching the lifeboat there, had proved problematic and, as the area could be covered by the Selsey lifeboat, closing the station made sense.

At Littlehampton, although the steamers operating from the port had been moved to Newhaven by the time the lifeboat station was opened, the number of sailing vessels using the port had increased from 200 to 250 and the port was getting busier. The RNLI Inspector stated that an efficient crew, made up of Coastguard and fishermen, could be obtained at the port, and he was looking for a suitable site for the boathouse. In October 1883 the Secretary of State for War authorised the construction of the boathouse on War Department land on payment of a nominal annual rent of 1s, and on condition that the site be given up without compensation should it be required for War Office purposes. A boathouse was subsequently built by J.A. Snewin, at a cost of £311 1s 7d. Work started in March 1884 and the building was ready five months later.

On 8 August 1884 the lifeboat was transferred to Littlehampton, under the supervision of the District Inspector, and placed in the new boathouse on skids; the carriage had been damaged during the journey from West Wittering and had to be returned to London for repairs. The first lifeboat was a 32ft by 7ft 6in ten-oared self-righter, built by Forrestt, of Limehouse, in 1865. She originally served Newquay in Cornwall, under the name *Joshua*, from 1865 to 1873. She was then transferred to Chichester Harbour, where she was renamed *James and Elizabeth*. For service at Littlehampton she was again renamed, becoming *Undaunted* having been appropriated to a gift of £400 presented to the RNLI to cover the cost of moving the lifeboat by Mrs Thornton West, widow of the late Richard Thornton West who had funded the Chichester Harbour station.

The public inauguration of the new station took place on 25 August 1884. Manned by a combined crew of local fishermen and Coastguards, the boat was taken round the town on her carriage, and then to Arun Parade, at the edge of the river Arun, where the District Inspector, Commander Nepean, RN, formally handed her over to the Local Committee. The Committee was represented by Mr Whitehead, Chairman of the Local Board; the Rev H. Mitchell, Honorary Secretary of the Chichester, Selsey and Littlehampton Branch of the RNLI; and Captain Hills, RN, Chairman of the sub-committee, all of whom made speeches. At the end of the formal proceedings the boat was launched, with the large crowd cheering the volunteers, who then gave a demonstration of the lifeboat's capabilities. The Chief Officer of the Coastguard at Littlehampton, W. Gould, was appointed as the station's first Honorary Secretary, with Charles Pelham as Coxswain.

Undaunted served at Littlehampton for only four years, during which time she answered just two service calls. The first came on 15 October 1886, when the barge *Matilda*, of London, got into difficulties off Bognor in heavy seas and a south-westerly gale. The lifeboat was launched, but the vessel got out of trouble unaided and the lifeboat returned to station without rendering any assistance. The other call came on 8 December 1885, when *Undaunted* was launched into heavy seas and a south-westerly gale to the assistance of the steamer *Henrietta*, of London, which was in difficulties off Kingston, to the east of Littlehampton. But again, the help of the lifeboat was ultimately not required, and so she returned to station.

James, Mercer and Elizabeth

In June 1887 the Chief Inspector stated that the lifeboat's self-righting capabilities were open to question, as the boat was by then more than twenty-two years old, and so the RNLI ordered a new boat for the station. The new craft, a 34ft by 7ft 6in ten-oared self-righter fitted with two water ballast tanks, was built by Woolfe & Son, of Shadwell. On 27 March 1888 she successfully passed her harbour trial on the Thames, and was then forwarded to her station on 7 May 1888. She was carried free of charge by the London, Brighton and South Coast Railway. The old lifeboat was sold locally, and the old carriage was returned to London, having been replaced by a carriage taken out of the Reserve Fleet. Built at a cost of £328, the new lifeboat was funded by a gift from Mrs Stoker, of Hull and, after due ceremony, was christened *James, Mercer and Elizabeth*.

James, Mercer and Elizabeth served at Littlehampton for just over sixteen years, during which time she launched ten times on service and is credited with saving twelve lives. Her first launch

took place on the morning of 11 November 1891, after the schooner *Young Karl* had been wrecked off Worthing, in heavy seas and a south-westerly gale. The Worthing lifeboat *Henry Harris* was launched, rescued the crew of seven and landed them safely. Another vessel, the barque *Capella*, then got into difficulties off Worthing. The weather had got steadily worse, so *Henry Harris* was readied for another launch. Meanwhile, *James, Mercer and Elizabeth* had put out from Littlehampton at 11.30am to help, but the Worthing lifeboat succeeded in rescuing the crew of seven from *Capella*. Conditions worsened while *James, Mercer and Elizabeth* was on her way to Worthing, and she could not return to Littlehampton so was beached at Worthing. Her launching carriage was taken by road to Worthing, where she was recovered and the lifeboat eventually returned to her station at 10pm.

When a vessel was seen showing signals of distress off Littlehampton on the evening of 14 August 1892, the lifeboat was called out at 10pm. In a southerly gale, *James, Mercer and Elizabeth* was launched and found the local yawl *Surf* about a mile south of the Coastguard station. There were two men on board, one of whom was taken aboard the lifeboat. Two of the lifeboat men boarded the yawl and, with the help of the rest of the crew, the vessel was brought into the harbour at 11.40pm.

In the early hours of 11 January 1894 signals of distress were seen off the West Pier so, at 1.50am, *James, Mercer and Elizabeth* was launched to investigate. The brigantine *C.H.S.*, of Llanelli, had hit the Pier, suffering considerable damage and damaging the Pier, after which she had run aground in heavy seas and a south-westerly gale. One of her crew had jumped onto the Pier

The self-righting lifeboats of the nineteenth century looked very similar, making it difficult to accurately identify individual boats. This is probably James, Mercer and Elizabeth, the second lifeboat to serve the station. She was a standard 34ft self-righter, pulling ten oars, of which more than 100 were built by the RNLI.

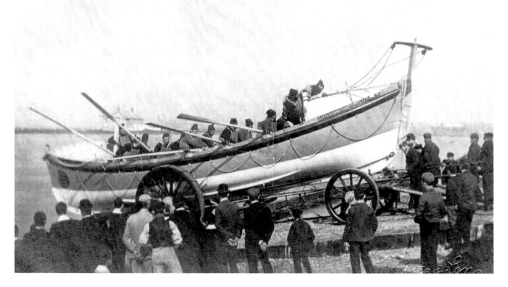

as the brigantine hit it, but six men remained on board the stranded vessel when the lifeboat reached her. Two refused to leave but, in the heavy seas, the lifeboat managed to get alongside and rescued the other four men, bringing them ashore at 3.30am.

Effective services, when the lifeboat actually assisted a casualty, were few and far between for Littlehampton's pulling lifeboats. Several launches were made to vessels reported to be in distress but which managed to get out of trouble unaided, or which were never found despite the best efforts of the volunteers, and sometimes these involved lengthy searches. A fruitless trip was undertaken by *James, Mercer and Elizabeth* on 1 December 1897 after a vessel had been reported in distress seven miles south-west of Littlehampton. The lifeboat was launched at 6.20pm and headed out into rough seas and a near gale-force northerly wind, but nothing was found and the lifeboat returned to station at 9pm. On 27 December 1898 the lifeboat had another fruitless trip, putting out at 12.30pm to the steamship *Lingfield*, of London, in heavy seas and a south-westerly gale, to the south-east. As the steamer got out of trouble unaided, the lifeboat returned to Littlehampton, arriving back at her station three hours after launching.

On the evening of 12 November 1901, during a severe south-westerly gale a distress rocket was seen about a mile east of the harbour by the Coastguard, who called out the lifeboat men and launchers. *James, Mercer and Elizabeth* was launched at 6.20pm and headed for the casualty, which proved to be the brigantine *Amy*, of Plymouth, bound from Sunderland to Exeter with a cargo of coal. The brigantine had run aground in the very heavy seas and only with considerable difficulty was the lifeboat manoeuvred alongside the stranded vessel to save the six crew. But the adverse tide and heavy seas prevented the lifeboat from returning to station and so she was beached at East Preston, about two miles east of the harbour, at 8.15pm and brought back from there to the boathouse by carriage.

What proved to be the last effective service performed by *James, Mercer and Elizabeth* took place on 26 February 1903. She launched at 1.30pm after the crew of the steamship *Brattingsborg*, of Copenhagen, had made distress signals. In very heavy seas and a full gale, the lifeboat men fought their way out to the steamer, which had lost her propeller in the violent seas, and stood by the crippled steamer until a tug arrived and took the vessel in tow to safety. Another launch took place on 31 October 1903, after the local schooner *Alice Moor* got into difficulties off the harbour in heavy seas and a southerly gale, but the schooner managed to get into the harbour unaided and the lifeboat returned to her station.

Brothers Freeman

In 1903, the last full year of service by *James, Mercer and Elizabeth*, plans were made to replace the lifeboat. In June the Local Committee reported to the RNLI that the Coxswain and crew wanted a boat fit 'for windward work', fitted with a centreboard to improve her sailing capabilities, similar to that at Worthing. Two months after this request had been made, the Director of Works of the Navy stated that a new Coastguard station was to be built on the site of the lifeboat house, and the site had to be surrendered to the Admiralty. A new site was made available to the RNLI and the following month plans were drawn up to reconstruct the boathouse on a new site. In January 1904 the RNLI's Corporate Seal was affixed to the lease of the new site and work got underway, being completed in March at a cost of £269 4s 3d.

Meanwhile, a new lifeboat had been ordered for the station from Thames Ironworks, of London, who were the RNLI's primary builders of lifeboats at the time. In November 1903 the new boat was appropriated to legacy of £2,000 bequeathed to the RNLI by the late

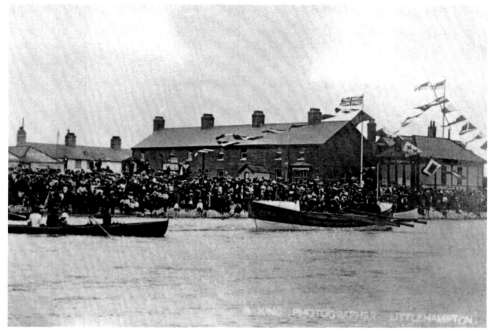

Francis John Freeman, of Abbey Road, St Johns Wood, in London, who wanted it to be named *Brothers Freeman*, and on 25 June 1904 the new 35ft by 8ft 6in ten-oared self-righting type lifeboat satisfactorily passed her harbour trial.

Brothers Freeman afloat in the river, probably during her naming ceremony in July 1904. The lifeboat house can be seen to the right. (By courtesy of the RNLI)

On 9 July 1904 *Brothers Freeman* arrived at Littlehampton having been sent from the capital by rail, being carried free of charge by the London, Brighton and South Coast Railway. Her new carriage, which had been built by the Bristol Wagon Works Co, of Lawrence Hill, Bristol, was sent from the West Country via the Great Western and London, Brighton and South Coast Railways. The old boat and carriage were returned to London. Built at a cost of £800, *Brothers Freeman* was formally christened on 10 August 1904 at a ceremony attended by the RNLI's District Inspector, as well as the Duke and Duchess of Norfolk. The boat was named by the Duchess, and the Duke made a short speech, with the event passing off 'in a successful manner', according to the Inspector.

Brothers Freeman arriving at Littlehampton, and her crew wearing their cork life-jackets. (By courtesy of the RNLI)

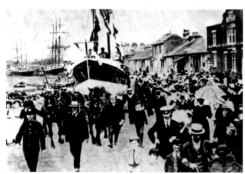

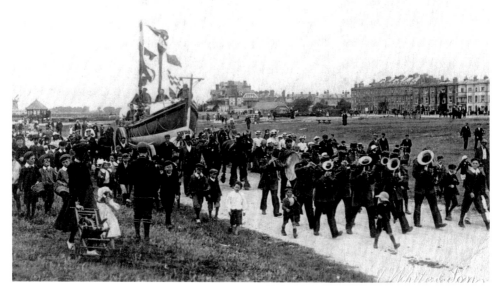

The inauguration ceremony for Brothers Freeman in July 1904 was well documented, and these three photographs show the new lifeboat on her carriage being paraded through the town (top) before the formalities (centre), which were followed by a launch (bottom). (From old postcards supplied by John Harrop)

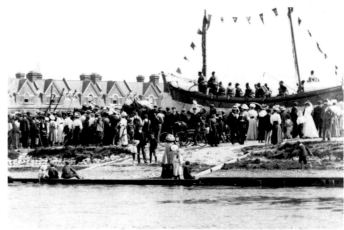

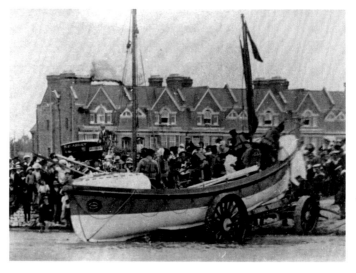

During her seventeen years on station, *Brothers Freeman* launched fourteen times on service and saved ten lives. Many of her launches were searches with nothing being found, and others ended without a rescue being completed. But she gave good service and was well used by her crew. Her first launch took place at 12.20pm on 20 August 1905, after the steam yacht *Cruban*, of Glasgow, had been sighted apparently in distress, in heavy seas and a south-westerly gale, about two miles off Selsey Bill. The help of the lifeboat was ultimately not needed and *Brothers Freeman* returned to station at 1.30pm.

When the steamship *Copeland*, of Glasgow, ran aground on Eastborough Ledge in dense fog on the morning of 4 March 1906, the crew of the nearby Owers Lightvessel fired their alarm gun. The Selsey lifeboat *Lucy Newbon* was launched, and *Brothers Freeman* put out at 9.30am. The casualty was refloated at 10.20am, but was then found to have sprung a leak. Accompanied by the Selsey lifeboat, she slowly headed towards Southampton, but *Brothers Freeman* returned to station, arriving back at 3.30pm after her crew had spent six hours at sea.

In heavy seas and a south-easterly gale late on the evening of 31 August 1906 a report was received that the steamer *Tuceu*, of Southampton, was possibly in trouble west of Selsey Bill. The Selsey lifeboat was already at sea, on service to the passenger steamer *Queen*, which had run aground to the east of the Bill and so, at 11pm, the Littlehampton lifeboat men and launchers were called. *Brothers Freeman* was hauled out of her boathouse and taken down to the water's edge, in case she was needed. The men waited until 2.30am, but as the casualty had got out of trouble, the lifeboat was taken back to her boathouse and all the men went home. They were called out again a few hours later, however, when *Tuceu* was again reported to be in trouble. *Brothers Freeman* was launched at 9.30am and was rowed down to the harbour entrance, remaining there in case her help was needed. But at 2.30pm it was confirmed that no further help was required and so the lifeboat was returned to her boathouse. During this launch, an unfortunate accident took place when one of the helpers, J. Reeves, was injured. He was in hospital for some time as a result, with the RNLI paying £7 15s od for the cost of his treatment.

On 19 October 1908 *Brothers Freeman* was launched at 8.45pm after the Coastguard had reported that the crew of a vessel, to the westward, were making signals of distress. In a strong south-easterly gale and heavy ground swell, the lifeboat made her way out to the casualty, the motor yacht *Swallow*, of Newhaven, with one man on board. The boat's propeller had broken and so the lifeboat men towed the yacht back to Littlehampton, arriving at 12.15am.

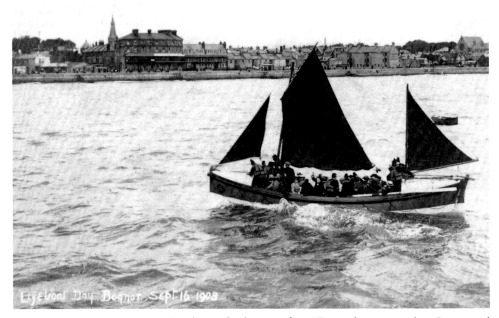
Lifeboat Day Bognor Sept. 16 1908

Brothers Freeman under sail off Bognor for the town's lifeboat day, on 16 September 1908. (Postcard supplied by John Harrop)

In the early hours of 10 December 1909 the Coastguard reported that warning signals were being fired by the crew of the Owers Lightvessel and flares had been seen coming from close to her. The Selsey lifeboat *Lucy Newbon* was launched, and *Brothers Freeman* put out at 4am, finding the ketch *Birthday*, of London, disabled with a broken rudder. The Selsey lifeboat returned ashore while a tug was summoned, and then went out again to stand by the ketch until the tug took her in tow. *Brothers Freeman* returned to station at 12.10pm.

At 8.55pm on 13 October 1910 the Honorary Secretary, Thomas Symes, received a telephone call from Selsey's Honorary Secretary

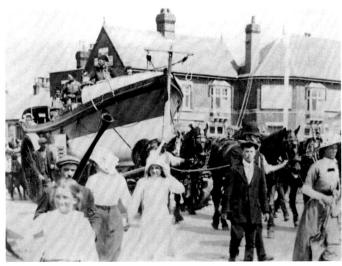

Brothers Freeman on her carriage being paraded through the streets of Littlehampton. (By courtesy of the RNLI)

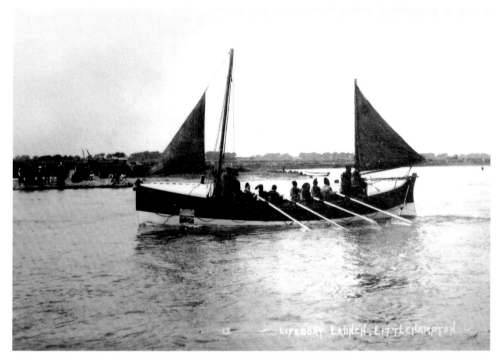

reporting that their lifeboat had just launched in response to signal rockets fired from the Owers Lightvessel. Mr Symes immediately went to the lifeboat house and the maroons were fired calling out crew and launchers. After the Coastguard reported sighting two more rockets fired from the lightvessel, *Brothers Freeman* was launched into the river from Arun Parade, at 9.45pm. Together with the Selsey lifeboat, the Littlehampton men made a thorough search of the area around the Owers Lightvessel in rough seas and a north-easterly gale, but found no vessel in difficulty. The steam tug *Jumna* had also put to sea from Littlehampton and, at the end of the search, towed *Brothers Freeman* back to harbour, arriving there at 2am after five fruitless hours at sea.

During the morning of 6 August 1912 the 800-ton barque *Anirac,* of Genoa, ran aground two miles off Littlehampton in extremely rough seas and a full south-westerly gale, and her rescue involved no fewer than three lifeboats as she drifted westward. However, she quickly refloated, but became unmanageable in the heavy seas and began to drift before the gale. *Brothers Freeman* was launched at 11.35am and reached the barque at 1pm. In the tremendous seas that were running, it took great skill and courage to manoeuvre the lifeboat alongside the disabled vessel, but nine out of the crew of fourteen were rescued, leaving the Master and other men who refused to leave. Just as *Brothers Freeman* got clear of the casualty, the Worthing lifeboat *Richard Coleman* arrived on scene and so, before leaving, Coxswain George Pelham informed

Brothers Freeman under sail off Bognor for the town's lifeboat day, on 16 September 1908. (Postcard supplied by John Harrop)

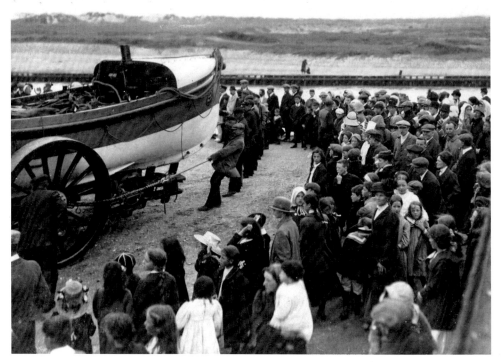

Watched by a crowd, Brothers Freeman being hauled out of the river following a launch. (From an old postcard supplied by John Harrop)

the Worthing men that five of the crew were still on the barque. *Brothers Freeman* returned to Littlehampton at 6pm, while *Anirac* continued to drift before the storm, with the Worthing lifeboat standing by her and, eventually, rescuing two more men. Shoreham lifeboat *William Restell* was also launched, at 2.20pm, being towed out to the drifting vessel by the local harbour tug. When she reached *Anirac*, the Worthing lifeboat returned to her station, and four Shoreham lifeboat men boarded the barque. They helped to connect a tow line from her to the tug and, with *William Restell* in close attendance, *Anirac* was eventually towed safely into Newhaven Harbour.

At 7.35am on 19 March 1913, the Selsey lifeboat was called out after a vessel was seen aground on the Mixen Reef in a south-westerly gale, with exceptionally heavy seas. As *Lucy Newbon* was launched, she was caught by the heavy surf and thrown back onto the beach, her crew only narrowly escaping serious injury. While work got under way to haul the lifeboat back up the beach and prepare for another launch, a message was sent to Littlehampton reporting the problems at Selsey and so, at 9am, *Brothers Freeman* put out. At the second attempt, the Selsey lifeboat got away safely and so *Brothers Freeman* was recalled by signal rocket, arriving back at her station at 11.45am. The casualty was the ketch *Gladys*, of Guernsey and the Selsey lifeboat stood by her until she refloated and was able to proceed on her way. The Littlehampton crew was

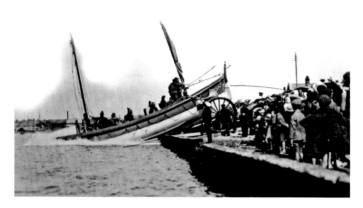

Brothers Freeman being launched on exercise at high tide from the slipway near the Windmill, watched by a large crowd for a flag day demonstration. (Postcard supplied by John Harrop)

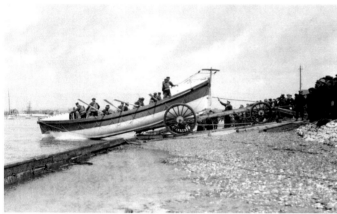

Another photo showing Brothers Freeman being launched, but without her masts raised. (Postcard supplied by Iain Boothby)

The 35ft self-righter Brothers Freeman putting to sea under sail. (Postcard supplied by John Harrop)

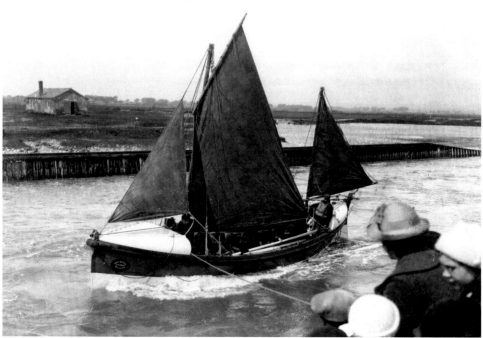

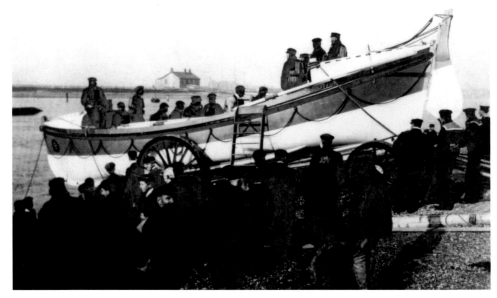

A crowd gathers to watch Brothers Freeman being launched. (Postcard supplied by Iain Boothby)

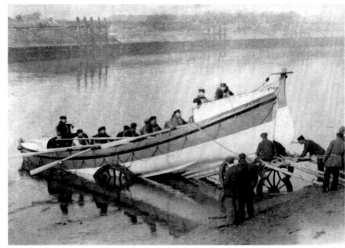

Brothers Freeman being launched into the river Arun on exercise. (By courtesy of the RNLI)

Brothers Freeman afloat in the river Arun ready for exercise. (Postcard supplied by John Harrop)

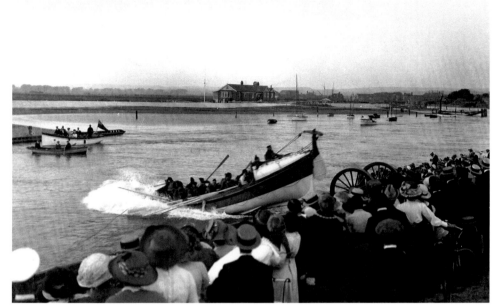

made up of George Pelham, Alonzo Allen, W. Hillman, G. Collins, G. Thompson, V. Pelham, G. Bowley, W. Burtenshaw, F. Burtenshaw, J. Smart, W. Goldsmith, J. Watts and A. Saunders.

Brothers Freeman undertook her last effective service on the afternoon of 24 October 1915. At 1.30pm two Government barges, *X94* and *X49*, were seen to be in difficulties nearly a mile off the harbour, to the south-west of the Coastguard Station. The lifeboat was launched at 1.45pm into a south-easterly gale, with rough seas and torrential rain. The Naval patrol boat *Ena* also put to sea and

Brothers Freeman being launched into the river Arun, possibly for a lifeboat day demonstration. (Postcard supplied by John Harrop)

Brothers Freeman under oars in the river Arun, passing the lighthouse. (Postcard supplied by Iain Boothby)

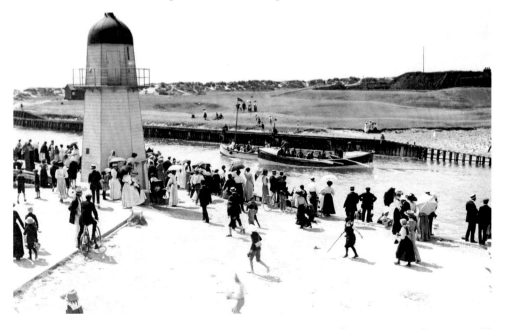

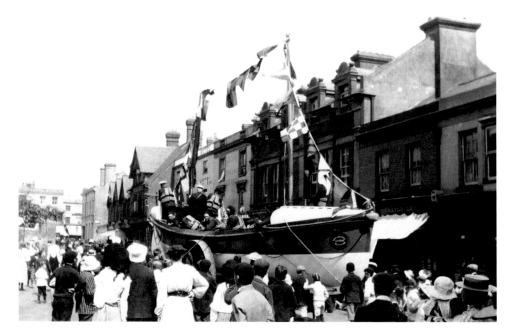

A sequence of photographs showing Brothers Freeman being taken along South Terrace for the station's annual flag day. These well attended events raised funds for the RNLI, promoted the work of life-saving at sea, and attracted local photographers to capture the events. (From old postcards supplied by Iain Boothby and John Harrop)

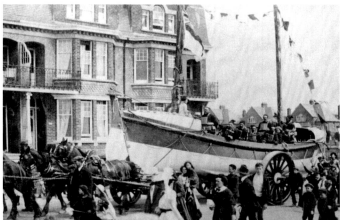

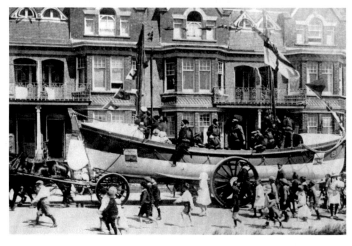

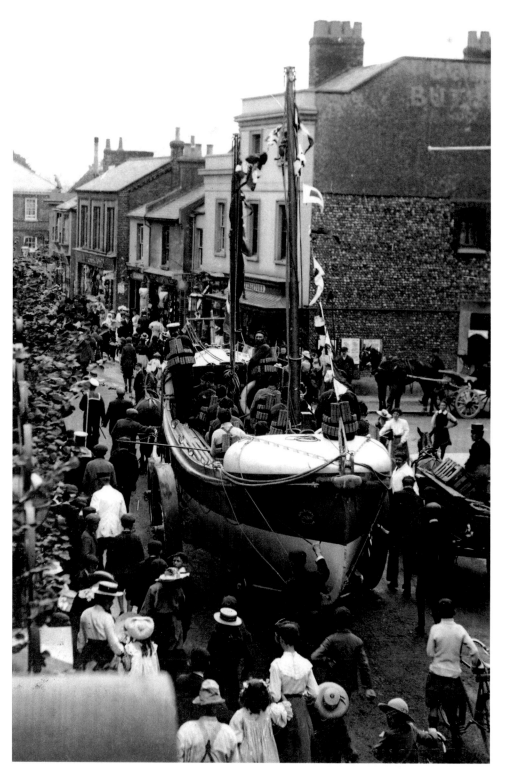

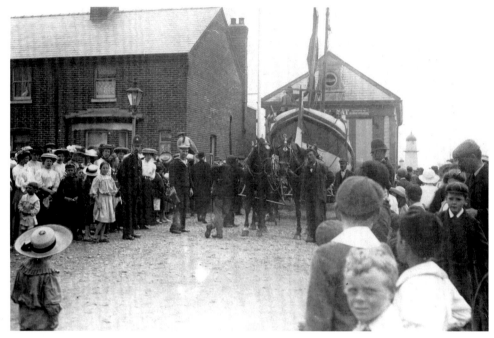

Watched by a large crowd, Brothers Freeman is brought out of the boathouse to be launched. (Postcard supplied by John Harrop)

she reached the barges first, finding that the engine of one of them had broken down. A tow line was passed across and secured, and *Ena* then towed the disabled barge into the harbour, followed by the other barge, with the lifeboat returning to station at 3.25pm having not been needed.

A couple more incidents followed in which the lifeboat's services might have been required, but neither came to anything. At 10pm on 27 April 1919 the local motor boat *Royal George*, with two men, a woman and a child on board and which had left the harbour at 7.45pm, was reported to be overdue. The Coastguard had the motor boat under observation and she appeared to have broken down and was drifting out to sea, so the maroons were fired at 10.45pm. Enough men turned up to form a crew, so the lifeboat was taken down to the water's edge and readied for service. But, just as she was about to be launched, a messenger arrived to say that the crew of the motor boat had managed to restart the boat's engine and she was being beached two miles east of the harbour, so the lifeboat was taken back to her boathouse at 11.15pm.

The last call came at 7am on 12 April 1920, when the barque *Pierre Antonine* was reported to be dangerously close to a lee shore in heavy seas and a south-westerly gale. The maroons were fired, calling out the lifeboat men and helpers, but the wind suddenly backed to south-easterly, which meant that the Worthing lifeboat was then the windward boat. Honorary Secretary Griffiths telephoned the Worthing station and was told that their lifeboat was indeed being launched. He was also told that a tug was on

its way and so he kept the Littlehampton crew on stand-by at the boathouse in case the barque signalled for help before the Worthing lifeboat could reach her. But no signal was received and so, as soon as the Worthing lifeboat was seen to be alongside the barque, the Littlehampton men were stood down.

Closure of the station

On 15 June 1920, two months after the service to the barque *Pierre Antonine, Brothers Freeman* was taken to Portsmouth Dock Yard for repairs, and she did not return until the autumn, by when the station's future was in doubt. In January 1921 it was reported to the RNLI that, owing to a bar, which had formed since the Admiralty had stopped dredging the river, it would be difficult to launch the lifeboat at low water spring tide in a southerly gale. Not only this, but finding a suitable crew had become difficult. During the First World War, when the Coxswains and some of the crew had volunteered for minesweeping, finding sufficient men to man the lifeboat had been manageable if difficult. However, on 18 February 1921 the Honorary Secretary, Mr Griffiths, reported to the RNLI that there were, 'no officers of the lifeboat and it is increasingly very difficult to form a crew owing to the men having to seek work elsewhere; the former officers had offered to man the boat for service should necessity arise'.

Due to the lack of crew, the station was temporarily closed in April 1921, and the District Inspector, Captain Basil Hall, RN, was

Brothers Freeman putting out to the Anirac, of Genoa, on 6 August 1912, from which she saved nine people. (From an old postcard supplied by John Harrop)

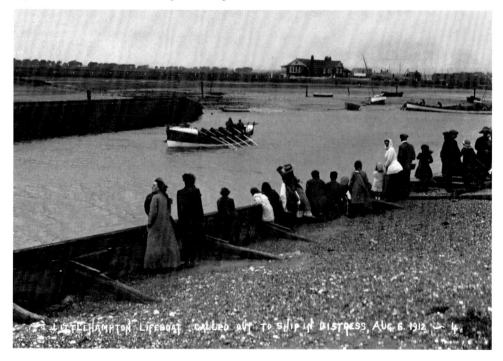

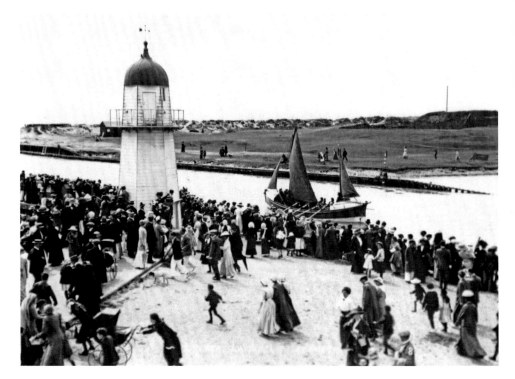

Brothers Freeman heading down the river Arun, passing the lighthouse, watched by a large crowd. (Postcard supplied by John Harrop)

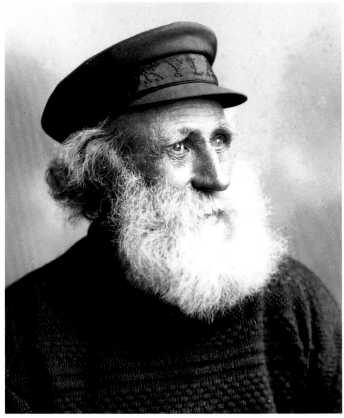

One of Littlehampton's best known lifeboat men in the pulling and sailing era was Charles Pelham, who died on 5 October 1929 aged ninety-three. At the time of his death he was the town's oldest resident. He was Coxswain from 1884 to 1897. His grandson, John Pelham, was a volunteer on the fist inshore lifeboats when the station reopened in 1967 (By courtesy of Littlehampton RNLI)

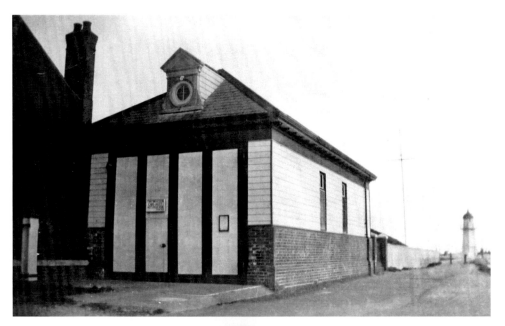

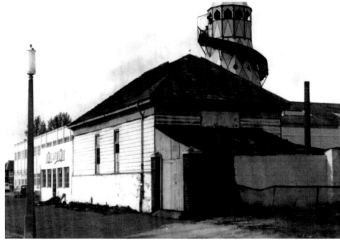

The lifeboat house of 1903, on the eastern side of the river Arun, pictured in April 1928 after the station had closed in 1921. It was in use as an ambulance garage. (Grahame Farr)

The lifeboat house of 1903 pictured in May 1962 after it had become a cafe. (Grahame Farr)

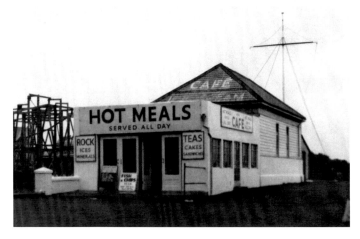

The lifeboat house, pictured from the north looking south, in May 1962 after it had become a cafe, which it remained until it was demolished. (Grahame Farr)

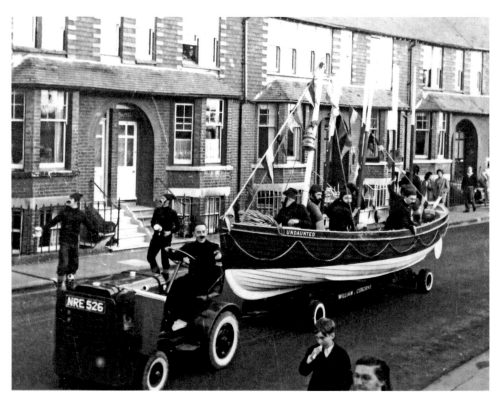

Even though there was no lifeboat at Littlehampton, this replica boat named after the station's first lifeboat, was on parade at the Littlehampton Carnival in 1958. (By courtesy of the RNLI)

instructed to determine whether it should be closed permanently. On 17 October he reported that there was very little shipping using the port, no suitable crew was available, and the Local Committee had passed a resolution to close the station. So, with plans already well advanced to place a motor lifeboat at nearby Selsey, in November 1921 the RNLI decided to permanently close the station. On 5 December 1921 *Brothers Freeman* was withdrawn, being sent to Plymouth the following year, where she served for another four years, and for almost fifty years Littlehampton was without a lifeboat. The lifeboat house was sold, and had a variety of uses, at one point becoming a cafe, until being demolished leaving no trace of the building.

Inshore Lifeboats

The reopening of the lifeboat station at Littlehampton came about following the introduction of a new type of lifeboat in response to an increase in inshore incidents needing lifeboat assistance, and as a result of fund-raising by the Blue Peter Television programme. In the 1950s and 1960s, more people began using the sea for leisure, taking to yachts, dinghies and surfboards, and lifeboats were increasingly tasked to help people who got into difficulty in relatively benign conditions close to the shore. Conventional lifeboats, being slow and usually requiring at least seven crew, were not well suited to dealing with such incidents. The RNLI soon realised that what was needed was a fast rescue craft which could respond speedily to incidents when a few minutes could make a crucial difference.

So, in 1962 an inflatable boat was brought to the UK for extensive trials, and a delegation visited France where similar boats has been used by the Breton Life-Saving Society, to see the inflatables in use. Following these initial steps, the first inshore rescue boats (IRBs) were introduced during the summer of 1963, with ten being sent to stations around England and Wales. Such was their success that more stations were supplied with the craft, and within three years the number of ILBs in service had risen to seventy-two. By the 1970s, when the inflatable ILB was

The original trials inflatable boat loaned to the RNLI by Alfred Schermuly, with Tony Wicksteed and David Stogdon testing her out of Littlehampton. The early ILBs were rudimentary inflatable boats crewed by two or three and powered by a 40hp outboard engine. They could be quickly launched, making them ideally suited for dealing with incidents such as people cut off by the tide, swimmers drifting out to sea and surfers in difficulty. The ILBs had a top speed of twenty knots, much faster than any lifeboat in service in the 1960s. (By courtesy of the RNLI)

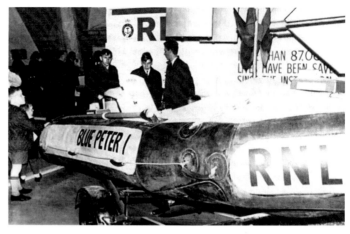

Blue Peter I, destined for Littlehampton, on display at the Earl's Court Boat Show in London in January 1967. (By courtesy of Jeff Morris)

Blue Peter presenter Valerie Singleton names Blue Peter I at Littlehampton, pouring milk rather than the more traditional champagne over the boat. (By courtesy of the RNLI)

an established part of the RNLI fleet and the small craft were performing hundreds of rescues annually, Littlehampton had joined the growing number of stations to operate the inshore craft, which has become the workhorse of the RNLI's fleet.

The first IRBs were manufactured by RFD and powered by a 40hp Evinrude outboard engine, which was not always reliable and sometimes difficult to start. On board, the compass was located in the middle of the floor mattress, making things uncomfortable for the helmsman who jarred himself on it when speeding over the

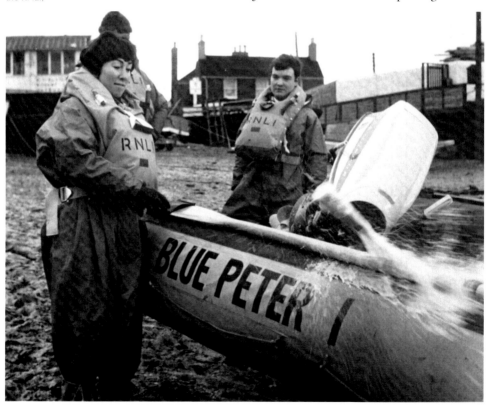

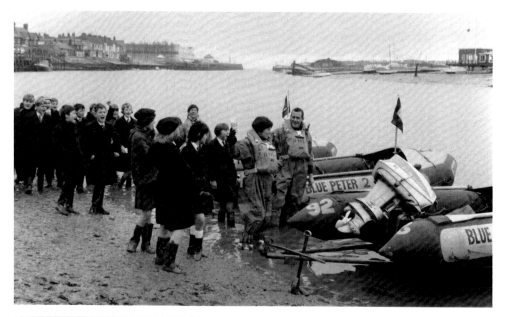

Blue Peter presenters Valerie Singleton and John Noakes with the new inshore rescue boats Blue Peter I, Blue Peter II and Blue Peter III at Littlehampton for a filmed launch at the conclusion of the programme's first appeal. (By courtesy of the RNLI)

A publicity photograph from the naming of Blue Peters 1, 2 and 3, when the boats were launched in 1967. Aboard the boat, with the supporting cast of local children, are George Moore and Valerie Singleton; the crew behind are Johnny Pelham, Dave Woollven and Roy Cole. Peter Robinson is kneeling in front of the boat. (By courtesy of Littlehampton RNLI)

The Blue Peter lifeboats: how it all began

The idea of a Blue Peter Lifeboat Appeal came about after Valerie Singleton, one of the programme's presenters, was driving to the studio and the programme on her car radio was interrupted by the words: 'Attention all shipping. Force ten gales are imminent'. Val recalled: 'Although a gale warning didn't worry me much I realised it could be life and death to anyone at sea. But when the RNLI told us how much a lifeboat would cost our faces fell'.

'£40,000', groaned John, 'we'll never raise all that.'

'But you might be able to get an inshore lifeboat,' said the man at the RNLI.

'How much is that?' We asked.

'£650, or 60,000 paperback books.'

'You're on!' We said. And the Blue Peter Lifeboat Appeal was launched.

The day after the appeal had been launched, the Blue Peter presenters were out with a horse and cart and twenty-three members of the 5th St Marylebone Sea Scout troop collecting books.

Val recalled: 'We all got freezing cold, including Seamus the pony, but we collected 500 books. It wasn't much, but it was a start.'

Meanwhile at the RNLI depot at Boreham Wood all the parcels of books were pouring in, and the following week the presenters went with some local children to help sort out the mountain of books that was growing bigger every day. Then three weeks later came the day we were to announce the result of the appeal. We rang the man at the RNLI and asked how we'd done.

'I think you might . . . Just hold on a minute.' The suspense was killing us. 'Yes, you've got three.'

'Three!' We could hardly believe our ears. All those books at Boreham Wood had made us feel optimistic but three boats was beyond our wildest dream. Next week we went down to Littlehampton for the launching ceremony.

As Blue Peter 1, 2 and 3 roared off into the English Channel, we really felt we were riding along on the crest of a wave. Three weeks later the telephone rang and it was the man from the RNLI again.

'You know those three inshore lifeboats,' he said. 'It seems there was some money left over after we'd bought Blue Peter 3, so we've added that to the money we collected when we showed Blue Peter 1 at the Boat Show.'

'Yes?'

'Well, you've got a Blue Peter 4!' Beyond a shadow of a doubt it had been our most successful appeal to date!

The Blue Peter lifeboats

Name	Station	Lifeboat type	Years funded
Blue Peter I	Littlehampton, Sussex	D class inflatable/Atlantic	1967–2016
Blue Peter II	Beaumaris, Anglesey	D class inflatable/Atlantic	1967–2010
Blue Peter III	North Berwick, East Lothian	D class inflatable	1967–2013
Blue Peter IV	St Agnes, Cornwall	D class inflatable	1968–2015
Blue Peter V	Portaferry, County Down	Atlantic	1987–
Blue Peter VI	Cleethorpes, Lincolnshire	D class inflatable	1994–2012
Blue Peter VII	Fishguard, Pembrokeshire	14m Trent	1994–

Blue Peter has held four fund-raising appeals for the RNLI, which funded twenty-eight lifeboats in total. In May 2007 Blue Peter received an RNLI Lifetime Achievement Award, which was presented by HRH The Duke of Kent.

waves. But the design of the boats was gradually improved, and more equipment, including VHF radio, flexible fuel tanks, flares, an anchor, a spare propeller and first aid kit, was added. The engines became more reliable, and were inversion proofed, and a method of righting in the event of capsize was developed. And, gradually, the inshore lifeboat, as the type was redesignated in the early 1970s, became a sophisticated rescue craft.

The opening of an inshore lifeboat station at Littlehampton in 1967 came about following an appeal by the Blue Peter Television programme, which first aired on TV in 1958 and became the longest-running children's TV show in the world. The show had made its first charitable appeal in 1962, and on 5 December 1966 an appeal was launched to fund an inflatable lifeboat for the RNLI. The appeal asked for 60,000 paperback books, which would be sold to raise money to fund the boat. However, the response from viewers was so overwhelming that, not one but four IRBs were provided, with almost a quarter of a million books being donated. Named *Blue Peter I* through to *Blue Peter IV*, the boats was stationed at Littlehampton, Beaumaris, North Berwick and St Agnes.

The boat destined for Littlehampton, *Blue Peter I,* IRB No.115, was exhibited at the Earl's Court Boat Show in January 1967, alongside the 44ft Waveney lifeboat *John F. Kennedy,* which had been allocated to Dun Laoghaire. *Blue Peter I* arrived at Littlehampton

Blue Peter presenters Valerie Singleton (in IRB nearest camera) and John Noakes on two of the Blue Peter craft in the river Arun. (By courtesy of the RNLI)

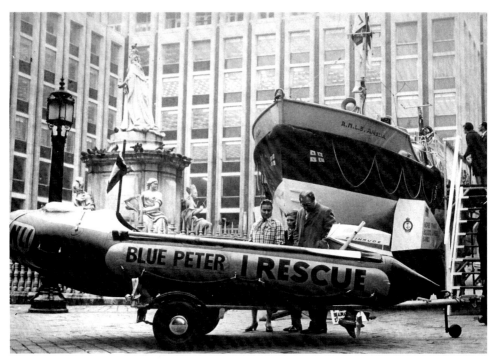

Blue Peter I on display outside St Paul's Cathedral in London in November 1968, with the 37ft Oakley class lifeboat Amelia, which had been built in 1964 but renamed Amelia in 1967. The Dean of St Paul's, the Very Reverend Martin Sulliven, conducted a service from the lifeboat on 12 November 1968. (By courtesy of the RNLI)

on the afternoon of Tuesday 18 April 1967, having been delivered by road from the RNLI Depot at Boreham Wood. Her crew were soon afloat on their first exercise under the guidance of the District Inspector of Lifeboats, Lt Cdr Bruce Cairns. Peter Cheney was appointed Honorary Secretary of the new station and among those in the first inshore crew was Johnny Pelham, grandson of the last Coxswain of the pulling and sailing lifeboat, George Pelham. A garage-type building was used to house the first IRB, which was launched from a trolley into the river Arun.

After a week of intensive training, IRB No.115 was declared operational, and less than a week later, on 7 May, the crew answered their first call. At 3.25pm that Sunday afternoon the Coastguard informed Peter Cheney that a sailing dinghy had capsized off the entrance to the harbour, in moderate seas and a fresh south-westerly breeze. Seven minutes later the IRB was launched and brought ashore the dinghy's two crew, with the IRB returning to her boathouse at 4pm, having completed the kind of rescue for which she was perfectly suited.

At 2.45pm on 17 June 1967 while at sea on exercise, the crew of IRB No.115 saw a girl on a raft waving for assistance. They went to her aid and found two girls on rafts unable to get back to the shore. They were taken aboard the IRB to be brought ashore and their rafts taken in tow. The IRB put to sea again straight away to help a boat belonging to the local sailing club which had picked up a man and two small boys from a pedalo. The boys were taken

BRITISH BROADCASTING CORPORATION
TELEVISION CENTRE WOOD LANE LONDON W12
TELEPHONE 01-743 8000 CABLES: BROADCASTS LONDON PS4
TELEGRAMS: BROADCASTS LONDON TELEX TELEX: 22182

"WHAT THE LIFE-BOAT SERVICE MEANS TO US"

To all of us on "Blue Peter" the Life-Boat
Service means our four "Blue Peter" Inshore
Rescue Boats. These boats, stationed at
Littlehampton, Beaumaris, North Berwick and
St. Agnes were bought with thousands of old
paper backed books collected by "Blue Peter"
viewers all over Britain. So far they've
saved 104 lives - 104 people are alive today
thanks to "Blue Peter" viewers who cared!

A letter from the Blue Peter presenters John Noakes, Peter Purves and Valerie Singleton which appeared in the January 1971 edition of The Lifeboat. (By courtesy of the RNLI)

aboard the IRB and brought ashore. Later the same day, the IRB brought ashore a young girl on a lilo, who had also been unable to return to the shore herself. Having completed three services in quick succession, the IRB was rehoused at 4pm.

Although the IRB had been christened *Blue Peter I* by Valerie Singleton, John Noakes and Peter Purves, presenters of the programme at that time, shortly after the boat had arrived on station, a formal service of dedication and handing-over ceremony was held on Saturday 5 August 1967. In front of a large crowd of residents and holiday-makers, two local school children, Susan Homer and Simon Whitehead, handed over the IRB to the RNLI, on behalf of Blue Peter viewers. The boat was accepted by Honorary Secretary Peter Cheney and, after a service of dedication conducted by the Rev L.J. Melliss, Vicar of St Mary's Church, Littlehampton, the new boat was launched into the river and her crew gave an impressive display of her capabilities.

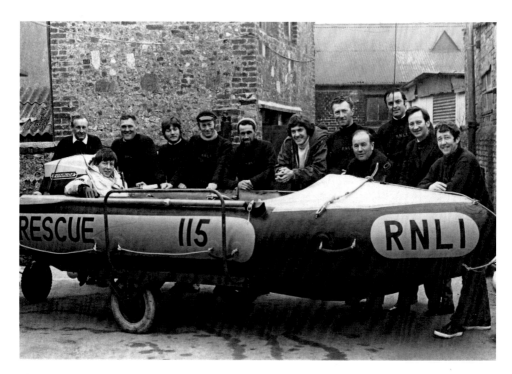

Above: IRB No.115
at Littlehampton, with
TV presenters John
Noakes (in the boat) and
Peter Purves (centre)
accompanied by some of
the crew. (By courtesy of
Littlehampton RNLI)

Right: IRB No.115 on
exercise. (By courtesy of
Littlehampton RNLI)

IRB No.115 on exercise
off Littlehampton. The IRB
was on service only during
the summer months, when
demand for its services was
greatest, and this season
usually lasted from March
to the end of October.
From the early 1970s the
station was operated all
year round. (By courtesy of
Littlehampton RNLI)

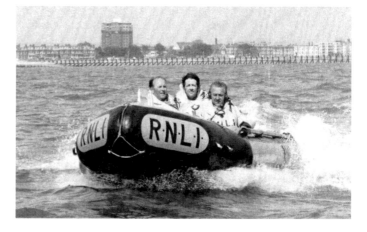

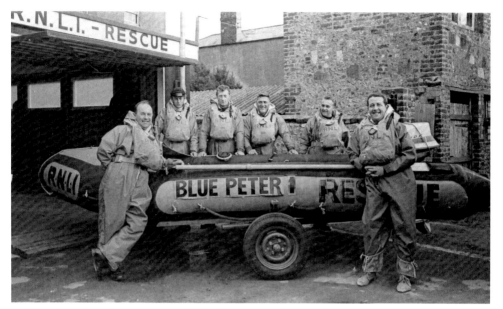

The day after the ceremony, IRB No.115 was launched on service at 3.38pm after a yacht had been reported in difficulties a mile south of Middleton-on-Sea. The casualty, *Dawn*, was found alongside the fishing boat *Teal*, which had also gone to her assistance. Two of the yacht's crew were taken aboard the fishing boat, and the IRB took the casualty in tow having taken off the third member of the crew. The dinghy was beached at Felpham and the IRB returned to station at 5.25pm.

The first call answered by *Blue Peter I* in 1968, her second year of service, came on 14 April, relatively early in the season, after the

Roy Cole, Johnny Pelham and Jim Raven outside the first ILB house with the D class inflatable No.115, the station's first inshore lifeboat. (By courtesy of the RNLI)

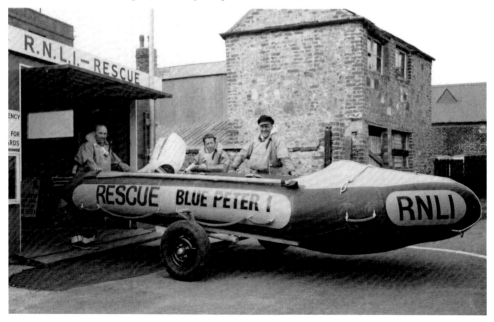

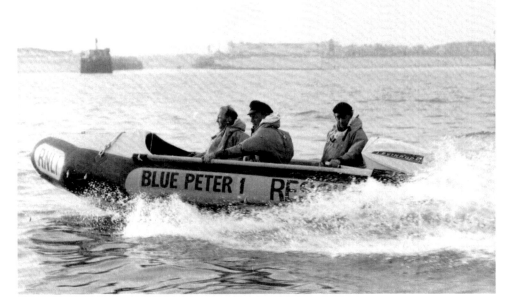

IRB No.115 on exercise off Littlehampton. The IRB was on service only during the summer months, when demand for its services was greatest, and this season usually lasted from March to the end of October. From the early 1970s the station was operated all year round. (By courtesy of Littlehampton RNLI)

Coastguard had reported that a sailing dinghy with two men on board had capsized off Rustington two miles east of Littlehampton. The IRB was launched at 11.38am, took the dinghy in tow and beached it safely. One of the men was suffering from shock and exposure and so both survivors were taken to hospital, with the IRB returning to station at noon, just twenty-two minutes after being launched on what proved to be a routine rescue. Among the other calls of 1968, *Blue Peter I* went to a couple of sailing dinghies on 28 July 1968, and undertook two rescues on 25 August 1968. The first was to a capsized sailing dinghy, from which the sole occupant was picked up, and the second, four hours later, was

In the foreground, Roy Cole and Dave Woollven bring ashore a raft, with George Moore standing by the D class inflatable D-115, which has been beached. A couple of lads had set off from the beach without any dependable form of propulsion on the raft and found themselves drifting around and unable to return. The ILB recovered them and the raft off Bognor. (By courtesy of RNLI)

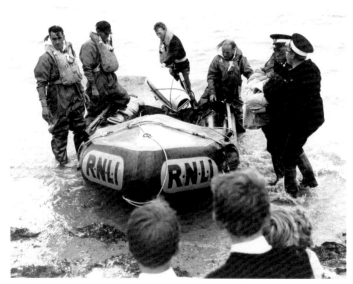

Two photographs showing lifeboat volunteers taking part in a joint exercise with St Johns Ambulance on the beach to the east of the harbour entrance. The lifeboat crew involved (in upper photo) are, left to right, George Moore, Peter Robinson, Dave Woollven and Roy Cole. (By courtesy of the RNLI)

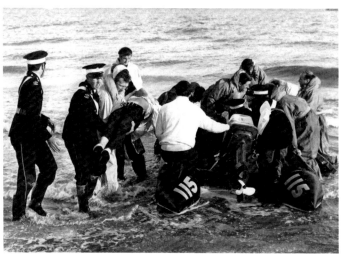

to a raft that was unable to make any headway about 400 yards south-west of the harbour entrance.

The afternoon of 10 May 1969 proved to be a very busy one for the crew of *Blue Peter I*. The IRB was launched at 3.11pm after a sailing dinghy had been reported in trouble east of the harbour entrance in a strong south-westerly wind and rough seas. On reaching the dinghy, the lifeboat crew were told by the owner that he could manage to get back to the beach unaided. But, as the IRB headed back to harbour, one of the crew spotted a capsized dinghy about half a mile away. Once on scene, two of the lifeboat crew jumped into the water and helped right the casualty, *Black Knight*, and, with her two crew back on board, towed the dinghy back to harbour. On returning to the boathouse, the crew were informed that another dinghy had capsized south-east of the harbour so the

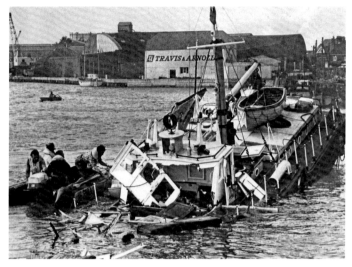

IRB was immediately relaunched. However, when they reached
the next casualty, they found the dinghy did not require help. The
crew of a large yacht then hailed the lifeboat crew and asked if
they would take ashore two crew who they had recovered from
the sailing dinghy *Holy Joe*. Both yachtsmen were suffering from
exposure and so they were taken ashore by the IRB. After assisting
several more capsized dinghies, *Blue Peter I* and her crew finally
returned to station at 4.48pm after a busy afternoon.

On 5 May 1970, while the Naval Torpedo Recovery Vessel
No.4424 was in Littlehampton Harbour for a training visit,
moored alongside the County Wharf, a violent gas explosion
ripped through the boat. It lifted her bows 25ft out of the water
and one of the two Naval Mechanics on board at the time was
seriously burned. *Blue Peter I* was launched at 3.50pm and, on
reaching the vessel, found that she was sinking. Crowds of horrified
holidaymakers watched as the IRB went alongside and her crew
climbed aboard to search for any more casualties. When it was

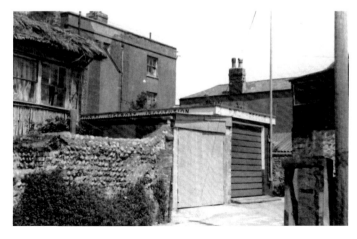

confirmed that all of the crew had been accounted for, the ILB helped the local pilot boat and the fishing boat *Patricia* tow the naval vessel to Fisherman's Hard, where she was beached, and the ILB returned to station.

In November 1970 a cyclone struck East Pakistan (now Bangladesh) causing widespread damage and severe flooding, and food and medical supplies needed to reach the large number of small communities that had been devastated. The British Red Cross put out an urgent appeal for help and, within thirty-six hours, the RNLI responded by providing twenty inflatable lifeboats, complete with engines and spares, to be airlifted from Stansted Airport to Dhaka. Two RNLI personnel, Lt David Stogden and Mike Brinton, flew out with the ILBs and, three days later, they were joined by two Littlehampton lifeboatmen, Roy Cole and Johnny Pelham. They were the first relief team to be sent to the area from Britain and, as well as training local Ranger Scouts in handling the high-speed inflatable boats, the RNLI men spent many uncomfortable hours taking supplies out to the isolated communities, eventually returning to Britain after two very hectic weeks. All four men were accorded the Thanks Inscribed on Vellum by the RNLI and also received Certificates from the Red Cross in recognition of their humanitarian work in East Pakistan.

The first Atlantics

During the early 1970s the station at Littlehampton was upgraded when a new and larger type of inshore lifeboat, designated the Atlantic 21, was sent there. The D class inflatables had proved to be very capable rescue craft but, while effective for daylight operation in moderate conditions, the 16ft inflatable had its limitations and a more sophisticated and capable type was sought which could operate in worse weather and at night. The RNLI experimented with the ILB during the 1960s, but eventually chose a design

One of the first Atlantic 21 ILBs to go into service, B-504 served at Littlehampton for just over a year before going to Hartlepool for a brief spell, and then into the Relief Fleet.

Above: Blue Peter presenter John Noakes looking out of a window above the river as the ILB is lauched, for the benefit of the TV cameras.

Right: Blue Peter presenter Peter Purves helps to push B-504 into the river.

Centre: Blue Peter presenters Peter Purves (left) and Lesley Judd (centre) help to launch B-504 while filming at the station for the TV programme in the early 1970s. (Photos by courtesy of the RNLI)

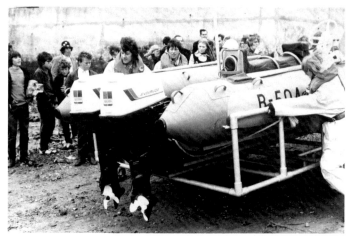

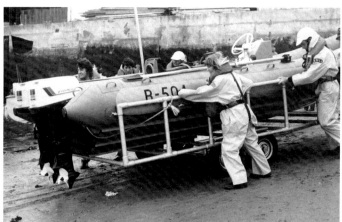

B-504 in the river Arun heading out to sea.
(By courtesy of the RNLI)

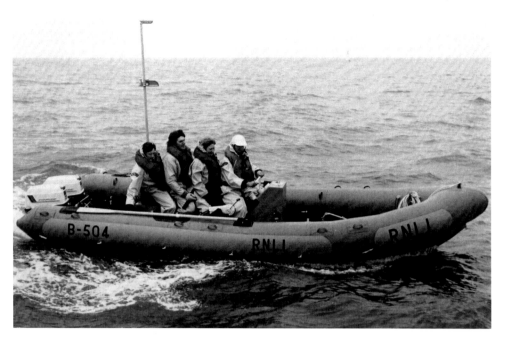

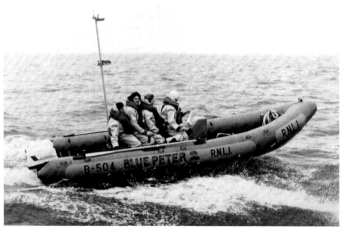

Two photos showing Atlantic 21 B-504 at sea with Blue Peter TV presenters John Noakes, Peter Purvis and Lesley Judd on board during filming for the TV programme. The photo (left) has been doctored with 'Blue Peter 2' added in pen. (By courtesy of the RNLI)

On board B-504, left to right, are John Noakes, Peter Purves and Lesley Judd; standing are, left to right, Stan Doe, Bill Porter, Mike Coombes, George Moore, Brian Pelham, Dave Woollven, George Barnes and Roy Cole.

Below: Lesley Judd takes a break during filming at Littlehampton.

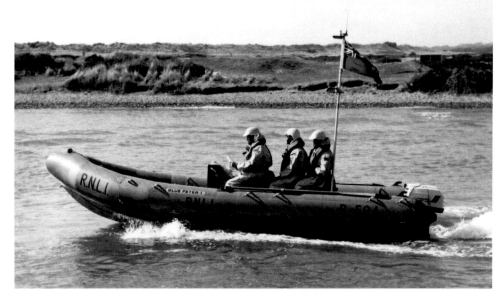

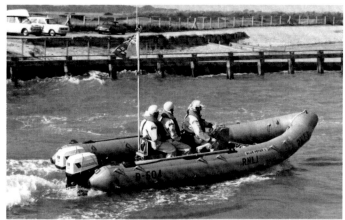

The first Atlantic 21 to be designated station boat at Littlehampton was B-504, and she is pictured on exercise in the river Arun shortly after arriving. The early Atlantics were fairly basic craft, with seating for the three crew in-line, and the navigation lights for night time work mounted on a mast at the stern. (By courtesy of the RNLI)

developed by Rear Admiral Desmond Hoare at Atlantic College, at St Donat's Castle in South Wales. The boat was a 21ft semi-rigid inflatable, driven by two 40hp outboard engines, giving a speed of about thirty knots. Crewed by three volunteers, the boat could put to sea in more challenging conditions than the single-engined inflatables. Much of the design work was undertaken at Atlantic College, and the craft was subsequently designated the Atlantic 21.

Trials with various boats of the new design took place at various stations around the coast, notably Lyme Regis, Hartlepool and Gorleston. In May 1972 the first Atlantic 21, number B-500, came to Littlehampton for trials and, the following month, the station received its own Atlantic 21, number B-504. She was given the name *Blue Peter I*, having been provided by the proceeds from a second Blue Peter TV Appeal, as well as a donation from the

Littlehampton Rotary, although she was never formally christened. She was the first of several Atlantic 21s to serve the station, with crew members helping develop and enhance the rigid-inflatable design, which has served so well for more than four decades.

B-504 *Blue Peter I* was on station for a little over a year, during which time she performed a number of rescues, including one on 16 July 1972 when she launched at 2.20pm to the aid of the rowing boat *Metzeler* with three people on board, in difficulties in choppy seas and a strong south-easterly wind. Those on board were rescued by the lifeboat and the boat was towed ashore. On the evening of 29 May 1973 B-504 *Blue Peter I* was launched in the evening to the 30ft fishing boat *Rock'n'Roll,* which had engine failure. She had six men on board and, in a heavy swell, the ILB went alongside and the lifeboat crew secured a tow line. The tow was very slow, but the lifeboat and casualty reached the harbour safely and the ILB was rehoused again at 9.25pm.

In July 1973 B-504 was replaced by another Atlantic 21, B-517, which also took the name *Blue Peter I.* The Atlantic type was being constantly developed and improved, and this later version was fitted with an air-bag, mounted on a roll bar over the outboard engines, which could be inflated by the crew in the event of a capsize to right the boat. As with the previous Atlantics that had been sent to Littlehampton, B-517 spent little more than a year on station. During the early 1970s, before a build programme for the Atlantics had been established by the RNLI, the boats were

Atlantic 21 B-504 being put through her paces off Littlehampton; this photo shows well the rigid hull and inflatable sponson. (By courtesy of the RNLI)

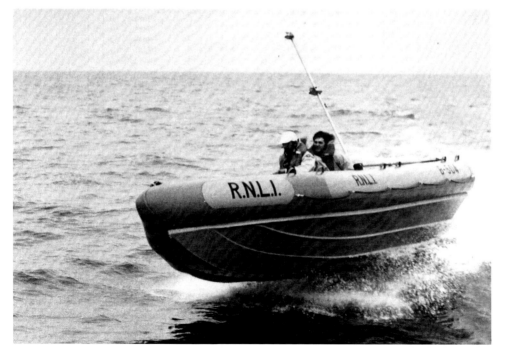

configured slightly differently and often went to stations on a temporary basis, to be replaced when another boat became available.

The first call answered by B-517 came on the afternoon of Sunday 22 July 1973, when her services were much in demand. She was launched at 12.30pm after a dinghy had capsized off Middleton. For the first time on service, the ILB was carrying qualified swimmers as part of her crew, and they picked up a man and a woman from the sea. These two people were then winched into a helicopter and landed on the nearby beach as, at 1.10pm, the lifeboat crew had been informed by radio that a boat was on fire off Angmering. On investigating, the crew found a motor boat had suffered engine failure and her crew had then fired a distress flare, the smoke from which had been mistaken by an onlooker on shore as a fire. The three occupants were taken off by a speedboat, crewed by another of the Littlehampton lifeboat men, and were transferred to the ILB and brought ashore.

The ILB put to sea again straight away and towed in the capsized dinghy from off Middleton. No sooner had this been done, than another call was received, so the ILB put to sea at 2.52pm to a capsized dinghy, saving a father and his seven-year-old son as well as their boat. The ILB, having been refuelled, was soon called out again, at 4.33pm, to another capsized sailing dinghy, whose two crew were rescued and their dinghy towed ashore. As the ILB returned to station, at 4.52pm, another call was received to a dinghy which had capsized, so her two crew and their boat were saved, with the ILB finally returning to her boathouse at 5.45pm.

In November 1974 B-517 was replaced by B-523, which again took the name *Blue Peter I*. By this time, the Atlantic 21 had been refined and the new boat was driven by more powerful outboard engines, each of 50hp. She also had the triangular seating arrangements for her crew which became the standard for the RNLI's B class rigid-inflatables, with the helm in front of two crew alongside each other. B-523 served at Littlehampton for more than a decade, and gave excellent service, proving that the Atlantic was the ideal type for operations off the Sussex coast.

In dense fog early on the evening of 17 April 1975, with visibility down to less than 200 yards, the local fishing boat *Hoppy II* broke down. Her crew of two radioed the Coastguard who alerted Honorary Secretary Peter Cheney. B-523 *Blue Peter I* was launched at 6.32pm, her crew having to be vigilant while leaving harbour in very difficult conditions. They were helped in the search for the disabled boat by another fishing boat, *The Baroness*, which was equipped with radar, and the casualty was eventually located and taken in tow by the ILB. As they headed slowly back towards harbour, the lifeboat crew received an urgent radio message from the men on board *The Baroness*. Their boat had hit a piece of wood and was rapidly taking in water. The boat's pumps were just about coping with the inrush of water, but the situation was becoming very serious. The lifeboat crew therefore cast off *Hoppy II* and escorted *The Baroness* into the harbour, returning straight away to *Hoppy II* and completed the tow job, reaching the harbour at 9pm.

On 17 July 1975 B-523 *Blue Peter I* carried out a very prompt service after a seventeen-year-old fisherman was injured in an accident on the trawler *Royal Escape*, seven miles offshore. He had been dragged overboard while shooting lobster pots. His two colleagues pulled him back on board but he had fractured his leg. They immediately radioed for help and the ILB was launched at 10.34am and rendezvoused with the trawler twenty minutes later. The injured man was transferred to the lifeboat and rushed ashore, where an ambulance took him to hospital.

On the afternoon of 19 June 1976 the crew of the dredger *Arco Trent* reported red flares nearly seven miles off Littlehampton fired by the 27ft yacht *Sal Volatile*, which was disabled with

On board B-523 Blue Peter I are, left to right, Mick Perry, Geoff Warminger and Peter Holliday as she blasts out of the harbour. (By courtesy of Littlehampton RNLI)

B-523 Blue Peter I at the mouth of the harbour with Jim Osborn, Dave Martin, and Geoff Warminger (helm) on board. (By courtesy of Littlehampton RNLI)

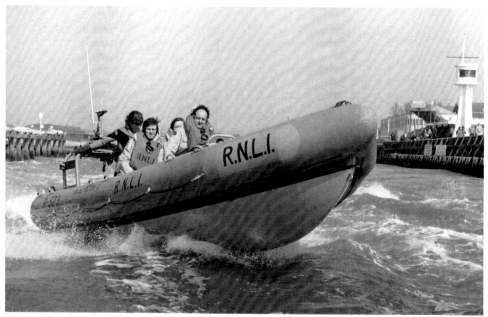

steering gear trouble in heavy seas and a westerly gale. In the prevailing conditions, the dredger was unable to get close enough to the yacht to take her in tow and so the Relief B-541, on temporary duty, was launched at 4.55pm. The lifeboat crew, after a very rough passage out to the yacht, helped to connect a tow line from her to the dredger, which slowly towed the crippled yacht into Shoreham Harbour escorted by the ILB, which returned to Littlehampton having spent three hours at sea in very arduous conditions. A Letter of Congratulations was later sent to the crew of the ILB by RNLI Headquarters for this very fine service.

On 7 March 1977 a diving trip off Littlehampton very nearly turned into a disaster for the three men involved. The weather had been fine but cold when the men had set out in their 18ft boat in the morning. After some time spent diving, the boat's engine stopped as a result of a fuel blockage. Two of the men were in the water at the time, one under water and some distance away. His colleague swam over to tell him of the problem, but by the time he had surfaced their boat with the other man still in it had drifted nearly half-a-mile away. With a strong tide running they were unable to catch up with the drifting boat and, although both were wearing full diving gear, they quickly began to feel the effects of the icy cold water. Their companion in the boat then sighted the dredger *Arco Yar* and fired distress flares, which were seen by the dredger's crew. They immediately altered course and informed the Coastguard, who alerted Peter Cheney and B-523 *Blue Peter I* was on her way at 12.07pm.

Meanwhile, the crew of the dredger picked up the man from the disabled boat and attempted to rescue the two divers from the water. The first man managed to climb about half way up a rope ladder, which had been lowered over the side of the ship, but his legs were so numb that he was unable to climb any further. A rope was lowered down to him and he managed to wrap this around his body and just held on. The ILB then arrived on scene and her crew cut the man free and took him aboard, with the other diver being rescued afterwards. By that time he had been in the water for two hours. Their colleague was taken off the dredger and they were all rushed ashore and taken to hospital by ambulance.

On 12 November 1978 the lifeboat crew joined in the Remembrance Sunday service, which was held at the local War Memorial. But just as the service was ending, the maroons were fired and the lifeboat crew made a discreet exit, hurrying to the boathouse. B-523 *Blue Peter I* was launched at 12.34pm to the 38ft cabin cruiser *Tango*, which had got into difficulties three miles offshore with one of her propellers fouled by a fishing net. The lifeboat crew found the cabin cruiser going round in circles in very choppy seas and a force six south-westerly wind. The propeller was eventually cleared and the boat was escorted into Littlehampton at 1.40pm.

A new lifeboat house

A new, larger boathouse was built at Fisherman's Quay in 1979, at a cost of £30,000, which was raised through local fund-raising efforts, to provide improved facilities and housing he the Atlantic 21. The new building was formally opened on 7 October 1979 in front of a large crowd, and a service of dedication was conducted by the Rev D.L. Satterford after which Her Grace Lavinia, Duchess of Norfolk CBE, President of the Littlehampton Branch of the RNLI, unveiled a Commemorative Plaque. Honorary Secretary Peter Cheney thanked all who had raised funds for the new boathouse, which was operational before the end of 1979. The new building was equipped with running water, showers, toilets, a galley and changing room, and was a great improvement on the previous building. A winch was also installed to replace the tractor used hitherto to launch and recover the boat.

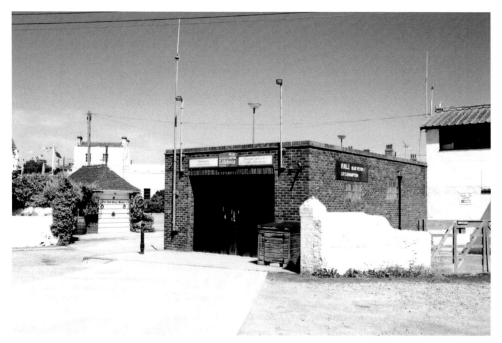

The Atlantic performed a couple of routine services in 1980. On the evening of 31 March 1980 she went to the new £13,000 ketch *Seahorse*, whose maiden voyage ended abruptly on a sand bank off East Preston. As the boat began to sink the owner fired a distress flare and, at 6.33pm, B-523 *Blue Peter I* was launched and rescued him. On 8 September 1980 the ILB was launched to help two men who members of the public walking along the seafront at Rustington had seen clinging to an upturned dinghy, a mile offshore. The ILB crew rescued the two men, who were exhausted and very cold, with one of the lifeboat crew having to go into the water to help get the men into the ILB.

On 7 November 1980, after two people were reported to be on the 23ft fishing boat *Kennel*, of Littlehampton, suffering from exposure and in need of immediate assistance, B-523 *Blue Peter I* was launched at 1.38pm. She headed out into a force five north-easterly wind, choppy seas and steady drizzle, and it was bitterly cold. The lifeboat crew found the fishing boat two and a half miles south-west of the harbour, and the two fishermen were taken aboard the lifeboat, with both of them suffering from hypothermia. They had been shooting their nets from a small dory when it suddenly capsized, but they managed to swim back to and clamber aboard their fishing boat. But they soon began to feel the effects of their immersion in the icy seas and radioed for assistance. Their condition was so poor by the time they radioed for help that their message was difficult to understand. One of the lifeboatmen was put aboard the fishing boat, and, while the ILB rushed the two

The ILB house built in 1979 was formally opened on 7 October 1979 and provided the volunteer crew with better facilities than they had previously. It was used for twenty-three years. (Nicholas Leach)

Below: cover of the programme issued for the opening ceremony of the boathouse, October 1979.

ROYAL NATIONAL LIFE-BOAT INSTITUTION
LITTLEHAMPTON BRANCH
SERVICE of DEDICATION
of the
LITTLEHAMPTON LIFE-BOATHOUSE

at
FISHERMAN'S QUAY, LITTLEHAMPTON

on
SUNDAY, 7th OCTOBER, 1979 at 11.15 a.m.

PROGRAMME – PRICE – YOUR GENEROSITY

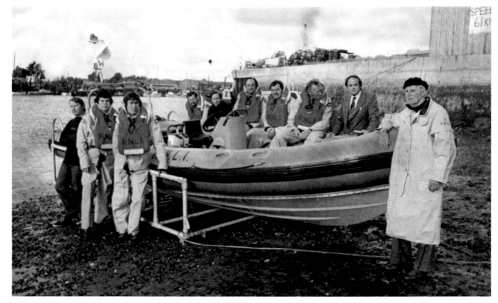

The lifeboat crew and B-523 Blue Peter I in January 1980. Pictured with the boat are, left to right, Bill Porter, Mike McCartain, Jim Osborne, Terry Wicks, Mick Coombes, Geoff Warminger, Dennis Vinehill, Dave Woolven, Peter Cheney (Honorary Secretary) and Stan Doe. (By courtesy of Littlehampton RNLI)

fishermen ashore, began a search for the dory. On admission to hospital, the fishermen were found to have a body temperature of only ninety-three degrees Fahrenheit. Meanwhile, the ILB had put to sea again with an extra crew member on board and eventually the dory was found and righted. The fishing boat was brought back to Littlehampton and the dory was towed in by the ILB at 4.15pm.

Vellum service to fishing boat

At 5.30pm on 19 September 1981 the weather suddenly deteriorated and caused havoc to a dinghy club meeting off Felpham. The club's safety boats were able to help various casualties but the assistance of the ILB was also requested. B-523 *Blue Peter I* was launched at 5.40pm, manned by helm David Woollven and lifeboat crew Geoff Warminger and Michael McCartain, and proceeded at full speed to the harbour mouth. Speed had to be reduced when heavy seas

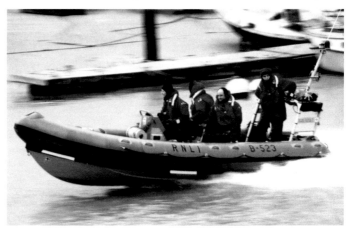

B-523 heading out of the harbour on service at speed. (By courtesy of Littlehampton RNLI)

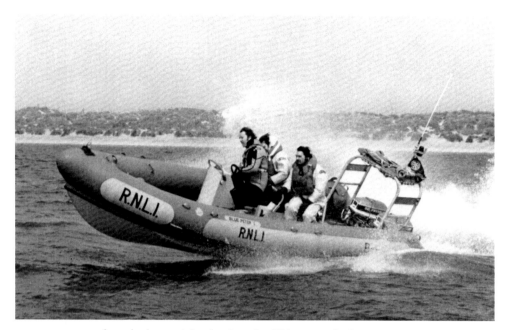

were encountered on the bar, and, by the time the lifeboat reached the scene, a mile and a half off Felpham, a force eight south-easterly gale was blowing, with heavy rain greatly reducing visibility. The local Coastguard radioed to say that all of the dinghies had been accounted for but a safety boat was missing.

As the lifeboat crew searched, it was confirmed that the safety boat had got ashore and so the ILB headed for the committee boat, the 40ft trimaran *Lora of Bosham*, which had a dinghy in tow, and was not making much headway. But in the heavy seas, the ILB was driven against the trimaran and her bow sponson was damaged, but the dinghy's crew of two, both suffering from exposure, were safely taken aboard. They were given life-jackets and survivor bags, and the ILB headed back towards Littlehampton. David Woollven

Atlantic 21 B-523 Blue Peter I served at Littlehampton for eleven years. (From an old postcard in the author's collection)

B-523 Blue Peter I being recovered onto the trolley at Fishermen's Quay after a service launch. (By courtesy of Littlehampton RNLI)

needed all his skill and knowledge to helm the ILB, which was steadily driven eastwards, using the wheel and engines to maintain course. Lifeboat man McCartain lay on the foredeck of the ILB cradling the heads of the two survivors to protect them from injury as the ILB pounded into the heavy seas, especially as she crossed the bar. But they entered harbour safely at 6.45pm and the two men were transferred to a waiting ambulance.

Five minutes later the skipper of *Lady of Bosham* requested immediate assistance as the trimaran was being driven onto a lee shore by the gale, which by that time had risen to storm force ten. The ILB immediately set out again, heading through waves up to 12ft high on the bar, to reach the trimaran at 7pm. Two women, both suffering from severe sea sickness, were taken aboard the ILB, placed in survivor bags and then brought ashore. In almost total darkness the lifeboat returned to the trimaran. With the wind having veered to the south-east, the casualty was able to make better headway. At 7.30pm, escorted by the ILB, she entered Littlehampton harbour, overcoming the heavy seas on the bar which made navigation extremely hazardous. By 7.40pm the trimaran was safely berthed and the ILB returned to her boathouse.

Following this fine service, Helmsman David Woollven was accorded the Thanks Inscribed on Vellum by the RNLI in recognition of his courage, fine boat handling and leadership, with crew members Geoff Warminger and Michael McCartain each receiving a Framed Letter of Thanks signed by the RNLI Chairman.

Lifeboat volunteers in the early 1980s; back row, left to right, George Barnes, George Moore, Jim Osborn, Mike McCartain, Mick Booker, Kingsley Cunningham, Richard Dixon, and Peter Cheney (Hon Sec); front row, left to right: Stan Doe, Jerry Norris, Dave Woollven, Ray Lee, Geoff Warminger, Dennis Vinehill and Dave Martin. (By courtesy of Littlehampton RNLI)

Above: Dave Woollven receiving his Vellum Certificate from the Duchess of Norfolk for the service in September 1981. (By courtesy of Littlehampton RNLI)

Left: The presentation of Dave Woollven's Thanks Inscribed on Vellum award, and the Vellum Service Certificates to Geoff Warminger (left) and Mike McCartain, by the late Lavinia, Duchess of Norfolk. Her husband was the 16th Duke, and at the time the Duchess was the station's branch president. After she died, her daughter, Lady Mary Mumford, now Lady Herries, became president.

Another good service was performed on 31 July 1983. At 2.10pm relief Atlantic 21 B-512, on temporary duty, was launched after a canoe had been reported in difficulties three miles west of the harbour entrance in moderate seas and a force four south-westerly wind. On reaching the canoe, the lifeboat crew found two young children, who were both very frightened. They were quickly taken aboard the ILB, and landed on the nearby beach. The ILB put to sea again later that afternoon to take part in a planned exercise off Bognor Regis, with a search and rescue helicopter. At 4.16pm, as she headed back towards Littlehampton, with conditions steadily worsening and the wind having risen to near gale force, a sudden thundery squall hit the area catching many small sailing dinghies at sea and many of them capsized.

A yacht had her sails blown out half a mile off Littlehampton Harbour, so the lifeboat crew assisted her crew before going to a Laser class dinghy, which was towed to the Yacht Club's safety boat, which in turn helped it ashore. The lifeboat crew were then asked to go to Bognor as quickly as possible, where a dinghy meeting had been taking place and fifty boats had capsized in the squall. The helicopter was also requested to assist. The lifeboat crew helped many of the dinghies and their crews to safety, and also the club safety boat, which was towing a boat ashore. By 6pm all boats and crews were safe so the ILB returned to Littlehampton. For this fine service, which saw the crew help a great many casualties, the RNLI's Chief of Operations sent a Letter of Appreciation, via the Honorary Secretary Peter Cheney, to helmsman Geoff Warminger and lifeboat men Jack Pidcock and Jerry Norris.

B-523 *Blue Peter I* was back on station for 1984 and launched at 4.54pm on 7 May after a person on Clymping Beach had contacted the Coastguard to report that a sailboard had capsized a

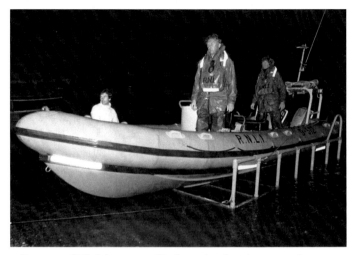

Atlantic 21 B-512 being recovered on the flat-bed launching trolley during her stint at the station in 1983. B-512 was built in 1973 and had a long career with the RNLI, serving into the twenty-first century after being formally named US Navy League in 1987. (By courtesy of the RNLI)

mile west of Littlehampton Harbour in choppy seas and a strong north-easterly wind. The sailboarder was rescued by the ILB and he and his board were landed on Clymping Beach, with the ILB returning to station at 5.30pm. She was launched again at 6.50pm after the parents of one person on an 18ft fishing boat had seen the boat capsize two and a half miles east of the harbour, and immediately telephoned the Coastguard. Three men, all wearing life-jackets, were found in the water and were quickly rescued and landed at the harbour by the ILB. An ambulance took them to hospital as they were suffering from cold and shock. The ILB put to sea again straight away to assist a cabin cruiser, and towed the capsized fishing boat to East Preston, where it was anchored.

B-564: the last Atlantic 21

In September 1985 a new Atlantic 21, B-564, arrived on station. This boat was again funded through an appeal run by the BBC TV's Blue Peter programme and was named *Blue Peter I* by Lavinia,

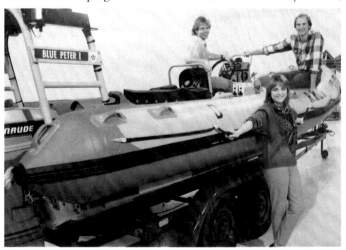

An Atlantic 21 in the BBC TV studios for Blue Peter in the mid-1980s, with presenters Michael Sundin, Simon Groom and Janet Ellis. (By courtesy of the RNLI)

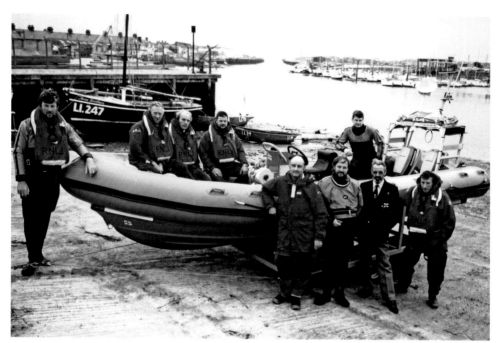

Duchess of Norfolk, at a ceremony on 26 April 1986. Chairman of the station, J.V. Forster, oversaw proceedings during the ceremony, with the lifeboat being formally presented to the RNLI by Samantha Bland, Andrea Westley and Peter Lavallee, pupils from Littlehampton School, on behalf of the BBC Blue Peter Television viewers. The service of dedication was conducted by the Rev Douglas Satterford, and the Duchess christened the new Atlantic at the end of the ceremony, after which the new boat was launched for a short demonstration.

B-564 served the station for sixteen years, and was the busiest of any of the lifeboats that had served the station hitherto. On the evening of New Year's Day 1987 the Coastguard informed Honorary Secretary Peter Cheney that an 18ft fishing boat, with two men on board, was overdue and this proved to be the start of a busy twenty-four hours for the Littlehampton volunteers. B-564 was launched at 9.10pm and the crew commenced a search south-west of Littlehampton, using parachute flares for illumination. The all-weather lifeboats from Shoreham Harbour and Selsey were also launched to search for the missing boat, using their radars, but it proved to be a fruitless task. B-564 returned to station at midnight to refuel, putting out again fifteen minutes later, but nothing was found and the search was discontinued at 3.15am. At 8.45am on 2 January the ILB was launched again after a Royal Navy helicopter saw the missing fishing boat three and a half miles south-west of Littlehampton. Both men were found to be well, but very cold, so their boat was towed to harbour by the ILB at 9.50am. The

The arrival of B-564 Blue Peter I, the third Atantic 21, on the day she arrived at Littlehampton in September 1985. Pictured with her are, left to right, Chris Shanks, David Woollven, Mick Perry, Mick Bentley, Geoff Warminger, Les Towse, Peter Holliday, George Moore and Michael Woollven. (By courtesy of Littlehampton RNLI)

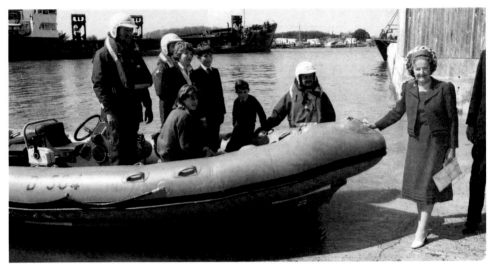

ILB was launched again at 3pm that afternoon after reports had been received that a rubber dinghy was adrift two miles east of Littlehampton, but the object proved to be an aircraft wheel, which was towed ashore, before the ILB was rehoused again.

When the fishing vessel *Challenger* began to sink on the Kingsmere Rocks, four miles from Littlehampton, on the morning of 1 May 1988, her crew of four put out a mayday call. B-564 *Blue Peter I* was launched at 9.20am and rescued the four men. Three of them were then winched into a helicopter and flown ashore, with the crew of the helicopter returning to the scene with a salvage pump. Meanwhile, the ILB took the fishing vessel in tow at 9.50am, but five minutes later the vessel sank, so the ILB landed the fourth survivor at 10.20am. The ILB was launched again at 3.44pm that afternoon to go to a capsized speedboat in rough seas and a strong south-westerly wind. Another speedboat saved one person and the lifeboat crew rescued a second survivor, who was clinging

Above: B-564 Blue Peter I bringing in a broken down motor boat. (By courtesy of Littlehampton RNLI)

Left: B-564 being winched slowly up the slipway, with Andrew Sleaman, Nick White and Mick Bentley on board. (By courtesy of Littlehampton RNLI)

Members of Littlehampton lifeboat crew with Pablo Severin. In the boat, left to right: Jerry Norris, Nick Bentley, Keith Hopper and Andrew Sleeman. Standing, left to right, are Ivan Greer, Pablo Severin and Terry Cobden. (By courtesy of the RNLI)

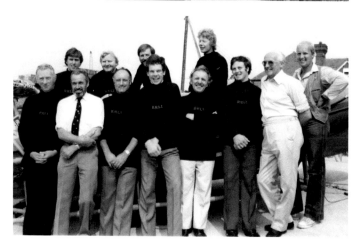

Lifeboat crew, circa 1983. On the boat are, left to right, Jim Osborn, Jerry Norris, Les Towse and Jack Pidcock; in front are, left to right, Dave Woollven, George Moore, Geoff Warminger, Mike McCartain, Bob Radford, Dave Martin, George Barnes and Mick Perry. Dave Woollven and George Moore were on the original crew in 1967, and George Barnes worked at Osborne's yard as one of the staff coxswains. (By courtesy of Littlehampton RNLI)

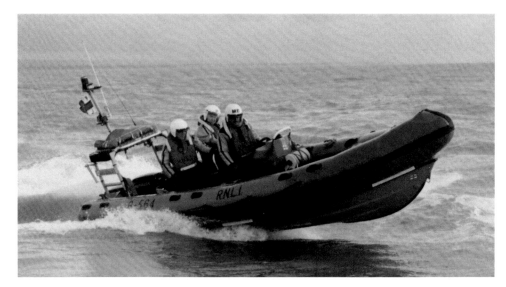

Above: Atlantic 21 B-564
Blue Peter I served at
Littlehampton from 1985
to 2001, and incorporated
various design improvements
over the earlier 21s that
had served the station.
(By courtesy of the RNLI)

Right/below: Atlantic 21
B-564 Blue Peter I being
put through her paces off
Littlehampton, June 1989.
(By courtesy of the RNLI)

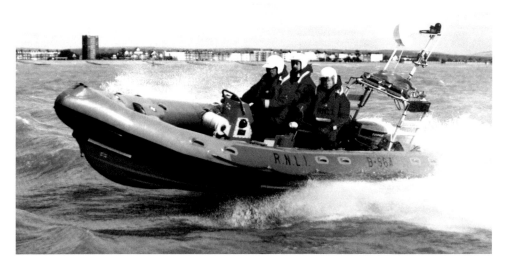

Visit by the Duchess of Kent in 1993. Peter Cheney was the station branch chairman and hosted the visit, with Paul Naish, Honorary Secretary, also in attendance. The current crew lineup was Dane Leekam, Steve Tester, Ivan Greer, Lee Hamilton-Street, Andrew Sleeman and Andrew Hooper, with four representatives of the original 1967 crew: Jim Raven, John Pelham, Roy Cole and George Barnes. (By courtesy of Littlehampton RNLI)

to the upturned boat. The ILB towed the boat into shallow water, where it was righted, and returned to her boathouse at 4.15pm.

At the beginning of 1993, Peter Cheney, who had served as Chairman of the Littlehampton Financial Branch from 1963 to 1978 and had been Honorary Secretary since the station reopened in 1967, was awarded a Bar to the Gold Badge that he had received in 1984. He retired as Honorary Secretary in 1993 to become Chairman of the Branch, and was succeeded by Paul Naish as Honorary Secretary. At the same time Stephen Strickland, who had

Littlehampton lifeboat crew, June 1989 • Front row, left to right: Dave Martin (later employed at RNLI All-Weather Lifeboat Centre, Poole), Peter Knight (later full-time crew on the Thames lifeboats and DLA), Jim Osborn, Geoff Warminger, George Moore (DLA), Bob Radford (shore crew), Terry Matthews, Peter Cheney (Honorary Secretary), George Barnes (DLA); back row, left to right: Jerry Norris, Colin Munroe, Terry Cobden, Les Towse, Nick White and Jack Pidcock. (By courtesy of the RNLI)

The 1979 lifeboat house pictured in May 1995 with revised RNLI signage above the door, and information panels along the side wall. (Nicholas Leach)

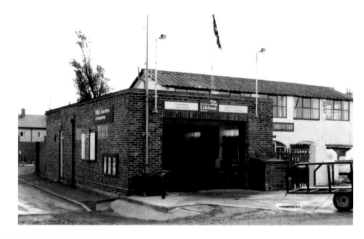

Atlantic 21 B-564 Blue Peter I putting out into the river Arun for a search in the river for a missing person in July 1995. (Nicholas Leach)

Atlantic 21 B-564 Blue Peter I putting to sea on exerise, July 1995. Keith Hopper is on the helm, with Lee Hamilton-Street to the right. (Nicholas Leach)

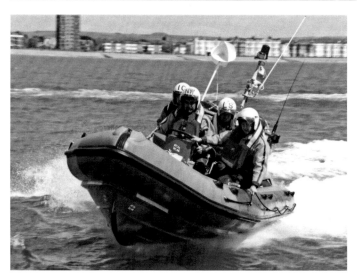

Atlantic 21 B-564 Blue Peter I putting to sea on exerise, July 1995, crewed by Keith Hopper, Ivan Greer and Lee Hamilton-Street, with Andrew Sleeman standing at the stern. (Nicholas Leach)

served as Honorary Treasurer of the station and financial branches since 1966, was also awarded a Gold Badge by the RNLI.

On the evening of 16 July 1993 a fine rescue was carried out near the station after several swimmers, in the sea near the West Pier, were caught by a strong tide and sea and swept them towards the Pier. All but two managed to get ashore safely, but one man and a teenage girl were swept against the Pier itself, both suffering severe lacerations from the barnacles. The alarm was raised at 8.45pm and B-564 *Blue Peter I* was launched within six minutes, soon arriving on scene and getting in close to the Pier so that lifeboatman Steven Tester could jump into the water. He swam across and quickly rescued the young girl. Once she was safely aboard the ILB, he swam back to the Pier, but the man was very reluctant to let go of the wooden pile to which he was clinging, despite his injuries. Eventually, he was persuaded to let go and was helped aboard the ILB, which landed the two swimmers at 9pm. Both were given first-aid and treated for hypothermia, before being taken to hospital by ambulance. For his courage during this rescue, Steven Tester was sent a Letter of Congratulations from the RNLI's Chief of Operations, Commodore George Cooper.

As preparations were being made to recover a small cabin cruiser onto a trailer at the public slipway at Bognor Regis early on the afternoon of 2 June 1995, the boat was swept away and, with her engine having previously broken down, the three people on board were in considerable danger as the surf was carrying the disabled boat towards the sea wall. B-564 *Blue Peter I* was launched from Littlehampton, and reached the cabin cruiser eleven minutes later. A tow line was immediately secured to the boat, which then had two people on board after one person had managed to get ashore. The boat was towed clear and the ILB headed back to Littlehampton, where the boat was berthed.

When a catamaran capsized off Bognor Regis on the afternoon of 26 May 1996, two jet-skiers went to the assistance of the crew. The jet-skiers jumped into the water and helped to right the catamaran. But the jet-skis then drifted away in the rough seas and south-easterly wind, leaving the men stranded in the water. The Coastguard alerted the Littlehampton lifeboat at 3.46pm, just as the station's open day was drawing to a close. B-564 *Blue Peter I* put out within four minutes, with the Selsey all-weather lifeboat also being called out. By 4pm the Littlehampton ILB was on scene and rescued the two jet-skiers, whose jet-skis were reported to have been washed ashore. The men, who were very cold, were landed at Bognor Regis and the ILB returned to Littlehampton half an hour later.

On 26 August 1996 the lifeboat crew had a busy afternoon. In choppy seas and a fresh south-easterly wind, an 18ft rigid-inflatable boat, with seven divers on board, broke down half a mile offshore, three miles west of Littlehampton so B-564 *Blue Peter I* was launched at 12.50pm and reached the disabled boat nine minutes later. A tow line was secured and the boat was towed back to Littlehampton Marina. As the ILB headed back towards her boathouse, the Coastguard requested the crew's assistance for a 17ft boat, which was in difficulties in the harbour. The ILB towed the boat to the Fisherman's Quay and returned to her boathouse at 2pm. She was called out again at 4.55pm to a small motor boat, which had lost its propeller after hitting the bar at the harbour entrance at low tide. The owner waded ashore to get help and the ILB towed the boat into deeper water and waited until the tide had risen sufficiently for it to enter the harbour in the late afternoon.

A Station for the Twenty-First Century

During the 1990s the RNLI undertook an extensive shoreworks programme to modernise boathouses and shore buildings, providing better accommodation for both the lifeboats and facilities for volunteer crew members. As larger all-weather lifeboats were being built, larger boathouses were needed at many stations, while for inshore lifeboats the rudimentary boathouses and facilities, which at many stations had been used since the advent of the inshore fleet in the 1960s, were upgraded with large purpose-built lifeboat houses.

Many ILBs had been housed in buildings little bigger than the boats themselves, with the crew gear hung on pegs around the walls. Training facilities were almost non-existent, and even at stations such as Littlehampton, where new boathouses had been built in the 1970s, facilities were not really suitable for the needs

The impressive lifeboat house, designed to house two inshore lifeboats, was built in 2001-02 on the site of the previous ILB house. (Nicholas Leach)

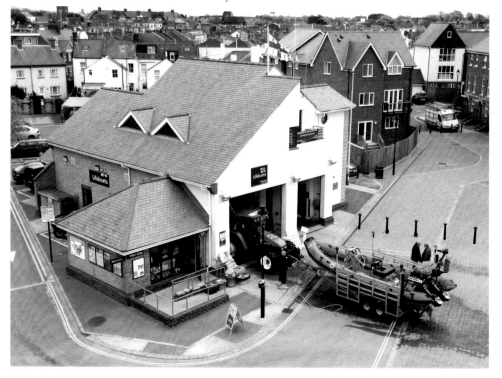

The new lifeboat house, built for two inshore lifeboats, was completed in June 2002 and is pictured in July 2002 before the road in front of it had been completed. D class inflatable D-433 Marjorie is being taken down the slipway to be launched. (Nicholas Leach)

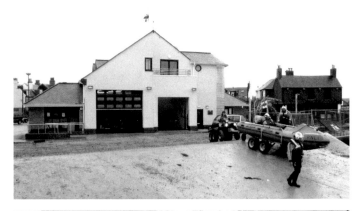

D class inflatable D-433 Marjorie being launched on exercise down the slipway, pushed by the six-wheeled Polaris vehicle that was supplied in 2002. This vehicle was soon replaced by a more powerful launching tractor (Nicholas Leach)

D class inflatable D-433 Marjorie putting out on exercise in the river Arun. (Nicholas Leach)

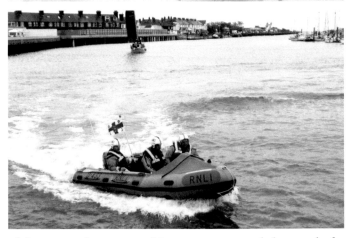

of the twenty-first century. More space was needed not only for larger lifeboats but also for launching vehicles and crew training.

So, work began at Littlehampton in 2001 on a new and impressive lifeboat station on the same site as the previous house, which was demolished. B-564 *Blue Peter I* was withdrawn once the work got underway and was replaced by the relief Atlantic 21 B-586 *Clothworker*, which had an anti-fouled hull and could thus be kept afloat. While the new boathouse was under construction the station temporarily relocated to the west side of the river,

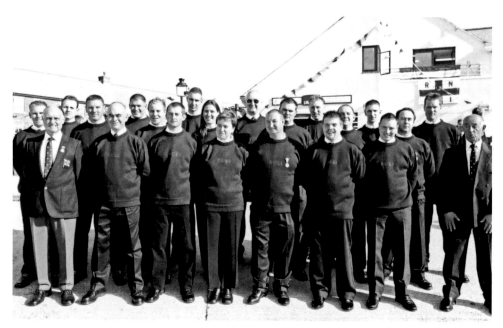

upstream from Osborne's boatyard at Cunningham Shipyard, using a pontoon mooring below the red footbridge, with two portacabins housing the equipment and changing facilities.

The new lifeboat house was completed in 2002 and the station became operational from there on 20 June, with the new Atlantic 75 B-779 *Blue Peter I* and a relief D class inflatable D-433 *Marjorie* on temporary duty, so the station had two inshore lifeboats to enhance its capabilities. The boathouse has been funded from the bequest of Mrs Mabel Davies, who also funded the launching equipment, and the new Atlantic 75 was funded from the Blue Peter Pieces of Eight Appeal, which had been run back in 1993. The 75 was an upgrade on the Atlantic 21, being not only larger and more powerful, but better equipped and with water ballast in the hull for better seakeeping.

The new *Blue Peter I* lifeboat, the sixth to be so named for the station, was formally christened and dedicated at a ceremony on 6 October 2003, when the new lifeboat house was also officially opened. Scheduled for an 11am start, the event did not get under way until after 11.30am because Konnie Huq, the Blue Peter presenter who was due to name the new boat, together with the TV crew filming the event, were delayed. Once proceedings began, the new lifeboat house was handed over by Lady Mary Mumford and the new lifeboat was formally presented by Konnie, who said: 'This has been the result of a long-running appeal started in 1966. Millions of viewers since then have organised many different fund-raising events. We have had a long and happy association with the RNLI since the original *Blue Peter 1* lifeboat was stationed

Littlehampton lifeboat crew at the naming of B-779 Blue Peter I, October 2002: Geoff Warminger DLA, Lee Hamilton-Street, David Snider, Nikki Hamilton-Street, Ivan Greer, Ross Bowman, unknown, John Jones (Hon Sec); middle row: Liam Clarke, Ritchie Southerton, Olly Clarke, Angela Gates, Gavin Simmons, Paul James and Peter Knight; back row: Gareth Flowers, Martin Blaker, Neil Moorling, 'Kerosene Ken' Greer, Andy Harris, Matt House and Oliver Griffiths. (Nicholas Leach)

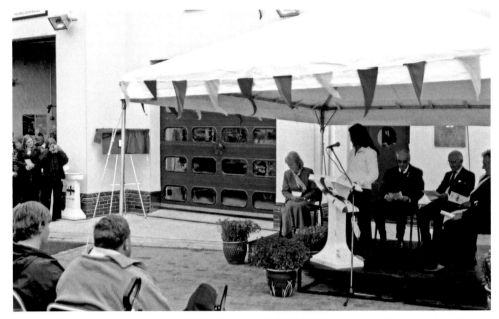

The scene (bottom right) during the naming ceremony of the new Atlantic 75 B-779 Blue Peter I and the official opening of the new lifeboat house on 5 October 2003, with Konnie Huq (above) addressing the crowd and then naming the boat (right).

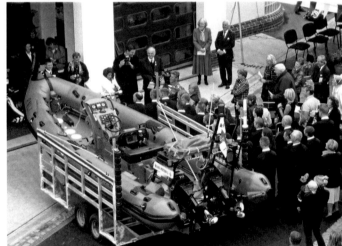

Below: Lady Mary Mumford formally opens the new boathouse on 5 October 2003 watched by a large crowd at Fishermen's Quay. (Nicholas Leach)

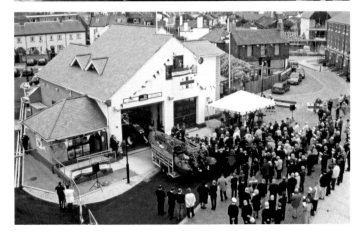

here in Littlehampton. I'm delighted to hand this new lifeboat into the care of the RNLI, where I'm sure she will help them to continue their lifesaving work in the future.'

After the service of dedication, Lady Mary Mumford unveiled a commemorative plaque and opened the new £550,000 boathouse, which was a far cry from the previous building opened by Lady Mary's mother, Her Grace, Duchess of Norfolk LG, in October 1979. After the new boathouse had been opened, Ms Huq then named the new lifeboat, pouring champagne across her bows and boarding it for a demonstration launch and run past for the benefit of spectators, with the Coastguard helicopter making an appearance.

The stationing of the second inshore lifeboat, a D class inflatable, at Littlehampton enhanced the capabilities of the volunteer crew. Operating an Atlantic and D class inflatable together had become relatively common practice by this time, and numerous RNLI stations, including nearby Portsmouth, Hayling Island and Calshot, were served by this combination of rescue craft. The first three D class ILBs at Littlehampton came to the station second-hand: D-433 *Marjorie*, funded from the bequest of Roger Newton May, was on station from June 2002 to 2003; D-431 *Veronica*, funded from the bequest of Miss Doris Veronica Tudor-Williams, served from 2003 to 2004; and between May and October 2004 the relief

Above left: Crew member Lee Hamilton-Street with Blue Peter presenter Konnie Huq after the ceremony and just before the presenter was taken out on the new boat.

Above: Lee Hamilton-Street and Peter Knight (later a DLA, and also full-time Thames lifeboat crew) on the boat watch as Konnie Huq clambers off; Ivan Greer (on left) and his father, Ken Greer (shore crew and tractor driver) provide a helping hand. (Nicholas Leach)

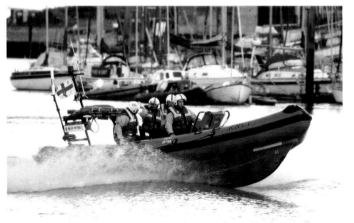

The new Atlantic 75 B-779 Blue Peter I is put through her paces in the river after her naming ceremony, with TV presenter Konni Huq enjoying the ride, 5 October 2003. (Nicholas Leach)

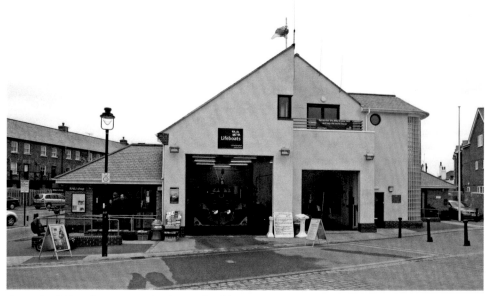

The modern lifeboat house at Fishermen's Quay, with boathalls for Atlantic and D class inshore lifeboats and their launch vehicles, a souvenir shop and crew facilities on the first floor. (Nicholas Leach)

D class inflatable D-458 *Maureen Samuels*, funded from the gift of Jim and Maureen Samuels was on station. D-433 had come to Littlehampton from the Relief Fleet, while D-431 had originally served at Clacton-on-Sea before going to the Relief Fleet in 2000, coming to Littlehampton three years later.

In October 2004 a new D class inflatable built for the station, D-631 *Spirit of Juniper*, was placed on service. The new ILB had been funded by the Campaign for Real Gin, which had its origins at the University of Cambridge, and which raised the money for the ILB during their Juniper Ball held in April 1999. The new ILB was formally named and dedicated at a ceremony on 21 May 2005 at which Branch Chairman Peter Cheney presided. Nick Ellis, on behalf of the donors, formally handed the ILB into the care of the RNLI, for whom she was accepted by Helen Griffiths and who, in turn, passed her into the care of Lifeboat Operations Manager John Jones. The service of dedication was conducted by the Rev George Bush, the Campaign for Real Gin chaplain, after which the ILB was launched for a short demonstration.

D-631 *Spirit of Juniper* served until July 2014 and performed many rescues, often working in tandem with B-779 *Blue Peter I*. The following accounts are only a small fraction of the many services carried out over the next decade, but are representative of the kind of work the Littlehampton volunteers undertook. The first service call on B-779 *Blue Peter I* was on 28 June 2002, when she went to a capsized sailing dinghy, with another call the following day involving a sick crewman on a chartered angling boat, which was caught in choppy seas. The first service call on D-631 *Spirit of Juniper* came on 21 November 2004, when she was

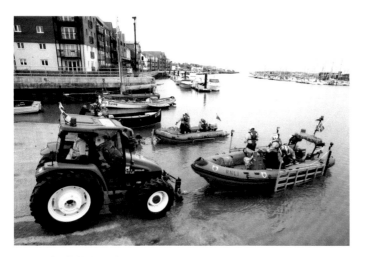

Atlantic 75 B-779 Blue Peter I and D class inflatable D-631 Spirit of Juniper launching together on exercise, 9 May 2010. (Nicholas Leach)

Atlantic 75 B-779 Blue Peter I and D class inflatable D-631 Spirit of Juniper launching together on exercise, 9 May 2010. (Nicholas Leach)

D class inflatable D-631 Spirit of Juniper heading out of harbour on a training exercise, 9 May 2010. (Nicholas Leach)

called out to a swimmer in trouble, but it proved to be a false alarm.

On 1 September 2008 Atlantic 75 B-779 *Blue Peter I* was launched to two casualties. The first was a 30ft wooden motor cruiser that ran aground attempting to enter the harbour, which lost steering and started to drift. Senior helmsman Andy Harris, with crew members Paul James and Clive Lindsell, took the ILB alongside the casualty to check the three occupants were safe, and then took her in tow towards Shoreham. Shoreham Harbour lifeboat was launched to take over the tow and rendezvoused with Littlehampton lifeboat off Lancing. Soon after transferring the tow, B-779 *Blue Peter I* was asked to help a 16ft fishing boat which had suffered engine failure. The vessel was quickly located and towed back to its moorings in Littlehampton harbour. The lifeboat and her crew were back and tucked up in bed before midnight.

On 27 April 2009 Coastguards requested that the lifeboat help a yacht in difficulty in gale force winds east of the harbour entrance. The 7.5m yacht, on passage to Brighton crewed by two men and a dog, ran aground as it attempted to take shelter in Littlehampton for the night. The following morning a passer-by noticed the yacht's crew were in difficulty and raised the alarm. Both the Atlantic 75 B-779 D class inflatable D-631 *Spirit of Juniper* were launched at 9am and were on scene within minutes. The conditions were harsh: torrential rain, gale force seven winds and rough seas were pounding the casualty. Lifeboat crew Jenny Cradock and Jon Maidment entered the water to deploy anchors and rig a towline to stabilise the yacht, and hold its bow into the weather. As the tide came in and the depth increased the lifeboats were able to carefully tow the yacht into deeper water and assess the condition of the occupants and their vessel.

With the wind and the sea pushing the boats, the tow into the harbour was very difficult, especially as the yacht had its steering jammed. A drogue was rigged and the D class inflatable took a line from the stern of the casualty to assist its directional stability through the turbulent currents of the harbour entrance. Paramedics were waiting at the boathouse to attend to the yachtsmen, who were hypothermic. Lifeboat Operations Manager Nick White commented: 'Our Atlantic helmsman Gavin Simmons, displayed excellent seamanship as he undertook a very difficult tow. It was an excellent example of teamwork, and this kind of thing is what our crews train so hard for.'

The year 2009 proved to be a very busy year for the station, and on 17 October 2009 came the 100th call of the year. The crew were called out at 11am to assist a vessel on passage to Shoreham. The 6.4m cruiser had broken down and was having electrical problems, but once crew members Ollie Clark, Andy Harris and

Atlantic 75 B-779 Blue Peter I and D class inflatable D-631 Spirit of Juniper on exercise off Littlehampton, May 2010. (Nicholas Leach)

Atlantic 75 B-779 and D class inflatable D-631 on exercise off Littlehampton, May 2010. (Nicholas Leach)

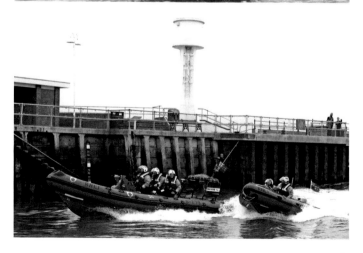

Atlantic 75 B-779 Blue Peter I and D class inflatable D-631 Spirit of Juniper at the harbour entrance as they head back to station, May 2010. (Nicholas Leach)

Above: B-779 Blue Peter I on exercise crewed by Lee Harrison, Ivan Greer and Andrew Harris on helm. (Nicholas Leach)

Right: B-779 Blue Peter I on exercise crewed by Andrew Harris on helm with Ritchie Southerton and Ivan Greer. (Nicholas Leach)

B-779 Blue Peter I on exercise crewed by Andrew Harris on helm with Ritchie Southerton and Ivan Greer. (Nicholas Leach)

Lee Cullen had located them off the coast of Goring, they towed them back to the harbour. Nick White commented afterwards: 'We have a dedicated team at Littlehampton who put a great deal of time into their training and are always willing to respond when they are needed. One hundred calls is a bit special; it is a record for us, and this year among the more routine tasks have been some shouts under very challenging conditions, or when the casualties were in serious danger.'

The ILB crew do not just face strong winds and high seas, but sometimes go out when the temperature has dropped below zero. Although the summer is their busiest time, the crew have tackled winter callouts bringing their own challenges. On 4 January 2010, with frost forming on the ground, they were tasked at 4.30pm to help a fishing boat in difficulty four and a half miles south of the harbour entrance. The 10m vessel had engine problems and was unable to make it back to Ford. With only three hours to low water, the priority was to get the boat over the bar while there was sufficient water. Atlantic 75 B-779 *Blue Peter I* was soon on scene, Selsey lifeboat *Voluntary Worker* was also tasked, and by 5pm the casualty vessel and her three crew had been located and were under tow back to the harbour.

Back on land, as the shore crew were manoeuvring boats on the moorings to make space for the casualty, they could smell smoke. They located a fishing boat moored nearby with an apparent engine fire so immediately called the fire brigade. With the first casualty safely moored further along the pontoon, crew Gavin Simmons, Ivan Greer and Andy Hicks then helped the fire brigade to pump out the second vessel. The lifeboat was back, refuelled and ready for service by 6.45pm, although washing the boat down proved something of a challenge as the water kept freezing on the hull. Nick White praised the team afterwards: 'Our crew and shore crew did a good job, not made easy by the freezing conditions.'

At the end of August and in early September 2011, the ILBs and volunteer crew had an exceptionally busy time, responding to nine

When the new lifeboat house was built, two tractors were supplied to make launching the lifeboats easier and safer. The smaller vehicle, number TA103, was supplied in 2003 and the larger vehicle, a Newholland TL80 type, number TA54, in 2002. (Nicholas Leach)

call-outs in seven days, which brought the total for the year to sixty-two services. The first incident came on Thursday 25 August 2011. B-779 *Blue Peter I* was launched at 10.53am to a cabin cruiser with a rope around its propeller and four persons on board, one of whom was seasick. Crew members Keith Booth, Andy Hicks and Lois Anderson soon reached the casualty four miles south-west of the harbour. Andy entered the water to cut the tangled rope from the propeller, after which the vessel was able to make its own way back to harbour, escorted by *Blue Peter I*.

The next call was two days later. While out on an exercise, the crew of B-779 *Blue Peter I*, Ivan Greer, Laura Robinson and Andy Hicks, spotted several capsized dinghies off Felpham. They recovered two children from the water and transferred them to the nearby safety boat before righting the overturned dinghies. Two calls came on Monday 29 August, with the first at 10.57am to a broken down dive boat, which was towed back to the harbour. The second was to a broken down motor, which was already under tow from a passing boat, so the lifeboat took over the tow.

The fifth call-out came on Wednesday 31 August at 6.04pm after an object had been seen in the water, five miles west of the harbour, approximately 500m offshore in the Bognor area, but a thorough search of the area by B-779 *Blue Peter I* proved fruitless. The next day D class inflatable D-631 *Spirit of Juniper* was launched at 10pm after a 999 call from a man concerned that his two brothers had not returned on their jet skis. The casualties were quickly located and one jet ski, which had broken down, was towed back to the harbour. The second jet ski also suffered engine problems and required assistance, so the crew towed them both back to the slipway outside the lifeboat station.

Two more calls came on Friday 2 September, with D class inflatable D-631 *Spirit of Juniper* helping dogs, in the morning and the evening. The dogs, Jess and Star, had gone for a swim in the fast flowing river Arun, but both were brought out safely by the lifeboat crew, to be reunited with their owners without much drama. The ninth and last call of this busy period came later on 2 September, with D-631 *Spirit of Juniper* being launched after a call from a lone man on board a 6.7m leisure boat, which was stuck on rocks with a rope around its propeller. The crew, Andy Harris, Lois Anderson and Andy Hicks, towed the vessel to deeper water to await the tide so that the casualty could get over the bar at the entrance to the river. Eventually, at 11.10pm, the boat was able to get over the bar and was then moored at the marina, with the ILB being refuelled and ready for service at midnight. Nick White said: 'It has been a busy time of late; the crew and shore crew are great guys and girls who give up a lot of their time. Hopefully things will quieten down now the summer holidays are over.'

At the end of August 2012 the volunteer crew experienced another very busy period, answering eight shouts in eight days. The first came on Saturday 18 August, with Atlantic 75 B-779 *Blue Peter I* being launched at 1.54pm to a broken down motor cruiser with seaweed wrapped round its propeller. The lifeboat began to tow the vessel back to its moorings at Shoreham until Shoreham's 16m Tamar class lifeboat *Enid Collett* met them en route to continue the tow. The next shout was at 3.49pm the same day, after a woman was reported to be in distress in the water at Bognor Regis, but the casualty made her way ashore by the time crew members Andy Harris, Warren Marden and Ross Bowman arrived in the ILB. At 4.20pm, en route back to Littlehampton, the crew found a broken down 18ft motor cruiser off Middleton-on-Sea with engine failure, so towed it to Fisherman's Quay.

On Sunday 19 August, while the same crew were at sea attending the Worthing Birdman rally, they spotted a rigid-inflatable in difficulty with a fuel blockage, so B-779 *Blue Peter I*

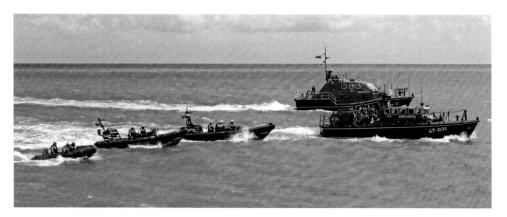

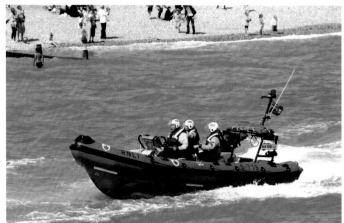

Atlantic 75 Blue Peter I (B-779) often comes to Selsey to attend Lifeboat Day, a major event at Littlehampton's flank station, and in August 2011 she was joined by lifeboats from the Hayling Island and Bembridge stations, which participated in a parade past the beach (bottom) and undertook various rescue demonstrations for the benefit of the crowds. (Nicholas Leach)

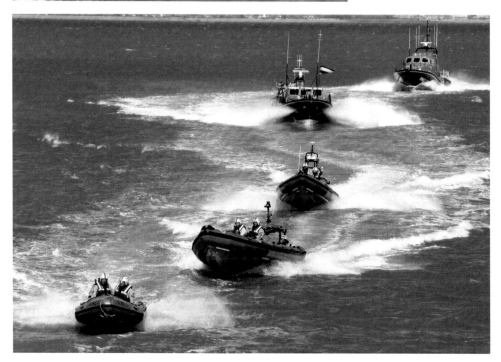

The new D class inflatable D-769 Ray of Hope on the day she arrived on station, 7 July 2014. Donors Ray and Val Humby with crew members Laura Robinson, Jon Maidment and Ivan Greer. (Nicholas Leach)

The new D class inflatable D-769 Ray of Hope on the day she arrived on station, 7 July 2014, with her predecessor, Spirit of Juniper (D-631), and Atlantic 75 Blue Peter I (B-779). (Nicholas Leach)

The new inshore lifeboat, D-769 Ray of Hope, returns to harbour after her first exercise launch, crewed by Olly Clarke and Jon Maidment with Ivan Greer on the helm, 7 July 2014. (Nicholas Leach)

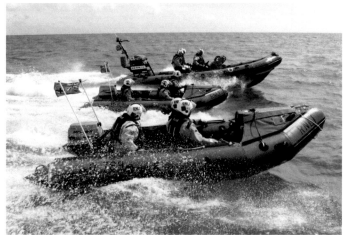

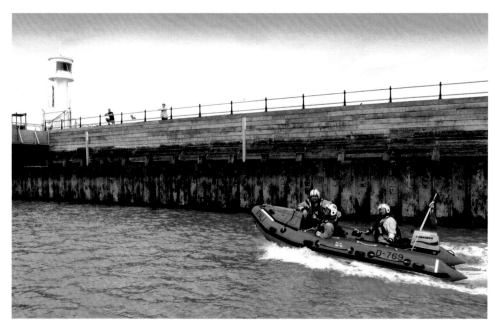

towed the vessel to her moorings at Littlehampton. Later that day the crew were tasked to another broken down vessel, six miles south-east of Littlehampton. The 4.5m motor boat had a flat battery, so the ILB towed the vessel back to Littlehampton.

On Wednesday 22 August D class inflatable D-631 *Spirit of Juniper* launched at 6.46pm to rescue Jessie the dog, recovering the animal from the fast flowing river and returning her to a much relieved owner on West Beach. On Friday 24 August crewmen Ivan Greer, Nick Miller and Lee Harrison launched B-779 *Blue Peter I* at 3.47pm to tow in a 10m yacht which had called for help after suffering engine failure in Littlehampton's harbour entrance. And finally, on Sunday 26 August B-779 *Blue Peter I* launched after a report of a near miss involving two swimmers and a vessel near the harbour entrance. The swimmers had disappeared by the time the Atlantic arrived, having swum safely ashore. LOM Nick White summoned up the events: 'It has indeed been a busy week, and shows the need for duty weekends throughout the summer when our volunteer crew, shore crew and launching authority take turns to be at the station constantly throughout the day and on call all night. We also rely on crew who work locally through the week and drop everything to be available immediately'.

In 2014 the station received a new inshore lifeboat to replace D-631 *Spirit of Juniper*, which had been on station since October 2004. The new ILB, D-769 *Ray of Hope*, was delivered on 7 July and became operational the same day. Her first service launch took place ten days later, when she launched just after 8pm to help

LMG chairman Mike McCartain addressing the crowd during the naming ceremony of D-769 Ray of Hope on 16 October 2014. (Courtesy of Eddie Mitchell)

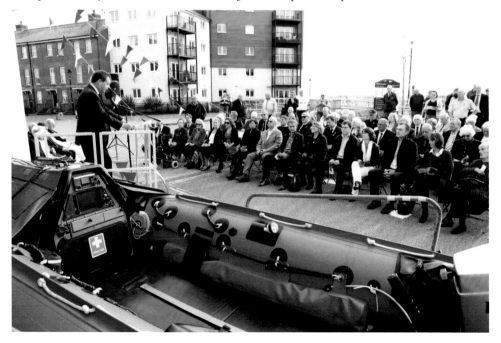

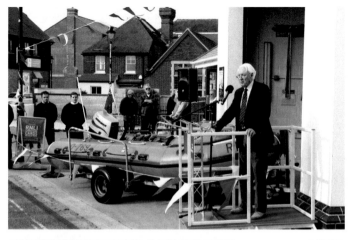

Donor Ray Humby addressing the crowd during the naming ceremony of D-769 Ray of Hope on 16 October 2014. (By courtesy of Eddie Mitchell)

Val Humby formally christens D class inflatable D-769 Ray of Hope at the end of the naming ceremony on 16 October 2014. (By courtesy of Eddie Mitchell)

Members of the Humby family with D-769 Ray of Hope, the boat they funded, on 16 October 2014. (By courtesy of Eddie Mitchell)

sailing dinghy that was in trouble. The relief Atlantic 75 B-773 *Duckhams 2001*, on station temporarily in place of B-779, was also launched and both ILBs helped the dinghy and its occupant.

The new boat was named at a ceremony on 16 October 2014 by Kent couple Ray and Val Humby, who were special guests of the station to officially christen the ILB that they had generously

funded. The pair, who live in Orpington, named the new ILB in front of family, friends and the station's volunteer lifeboat crew. Between July, when the boat arrived, and the ceremony, the volunteer crew launched her fourteen times.

Addressing the audience during the ceremony, Ray said: 'It is really great to have the support of friends and family today. Today feels a bit like the end of a project – in 2009 we offered to fund a lifeboat and, while it was a no-strings attached donation, we wanted it to go to a lifeboat station we could have a relationship with. Two years ago the RNLI said Littlehampton's lifeboat was due for replacement – and the relationship is exactly what we wished for. They have been so friendly and really welcomed us and made us feel at home. It gives me very great pleasure to be offering this lifeboat to the RNLI.' The honour of christening the ILB with the traditional pouring of champagne over the bow went to Val.

End of an era

In May 2016 the era of Blue Peter lifeboats at Littlehampton lifeboat station came to an end when the station's new Atlantic 85 lifeboat arrived. Blue Peter-funded boats had been at the station for forty-nine years, but the new Atlantic, B-891 *Renée Sherman*, became the station's first Atlantic lifeboat not to carry the name *Blue Peter I*. In all, five Atlantic lifeboats to serve the station were named *Blue Peter I* and the departure of the Blue Peter lifeboat was marked by a special live TV broadcast from the station.

B-891 arrived at Littlehampton by sea from Cowes at 12 noon on 16 May 2016 and was greeted by the boat she replaced, B-779 *Blue Peter I*, and the D class inflatable D-769 *Ray of Hope*. The new 85 could hardly have been more different from the first Blue Peter lifeboat, which was a single-engined inflatable. Not only was she considerably larger, but she was also much more powerful, being fitted with twin 115hp Yamaha four-stroke outboards giving a top speed of well over thirty knots. The Atlantic 85 was an upgrade

B-779 Blue Peter I and D-769 Ray of Hope head out to greet the new Atlantic 85 B-891 Renée Sherman as she arrives from Cowes on 16 May 2016. (Nicholas Leach)

on the Atlantic 75, and represented the third generation of B class lifeboats used by the RNLI. She carried more equipment: as well as intercom communications for the crew, the VHF radio was used via helmets, and there was also DGPS, chartplotter, a searchlight, night-vision equipment and paraflares for night operations, and a seat for a fourth crew member. The hull was constructed of fibre reinforced composite, with Hypalon used for the sponsons.

The new lifeboat arrived on 16 May and, following a week of intensive training and familiarisation for all the volunteer crew, she was officially placed on station three days later, with B-779 *Blue Peter I* leaving by road to take up a new role in the Relief Fleet. Within two weeks of her arrival, B-891 *Renée Sherman* was in action, launching just after midnight on 27 September 2016 following a call from West Sussex Police to the Coastguard. The lifeboat headed out in the dark upriver towards a reported incident on the A259 river bridge. Once on scene, the volunteer crew were informed that the police had dealt with the incident, so *Renée Sherman* was stood down and at 1am returned to station.

The new Atlantic 85 was funded from the legacy of Renée Sherman, of Wiltshire, who left a gift to the RNLI in her will when she died in 2012. Although Renée spent much of her life in Wiltshire, where she worked as a teacher, she was born in France, and was a young woman when the Dunkirk evacuation took place in 1940. Nick White, Lifeboat Operations Manager, said 'Mrs Sherman's kindness will help save lives at sea for many years to come, and is a lasting legacy to her generosity'. Renée was

The new Atlantic 85 B-891 Renée Sherman arriving at Littlehampton from Cowes on 16 May 2016. She is larger and more powerful than any of her predecessors, with twin 115hp outboard engines, a crew of four and the latest electronic navigation and communication equipment. (Nicholas Leach)

The new Atlantic 85 B-891 Renée Sherman arriving at Littlehampton on 16 May 2016, with her smaller predecessor, B-779 Blue Peter I. On the Atlantic 85 were Andrew Harris (helm), Tom Pederson (RNLI staff trainer/assessor) and Ivan Greer; on the Atlantic 75 were Warren Marden, Richard Winstanley and Ross Bowman on helm. (Nicholas Leach)

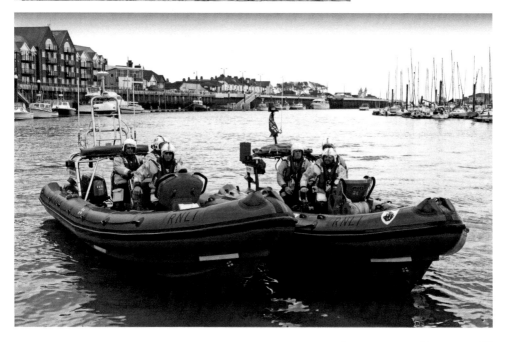

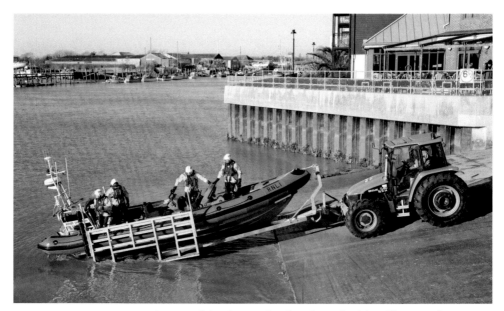

B-891 Renée Sherman being launched on exercise down the slipway into the River Arun, December 2016. (Nicholas Leach)

interested in the work of various charities. She was always very generous and thought highly of the RNLI. The new lifeboat was originally going to be named after her husband, Jack Sherman, who was Jewish and lived in Germany, but managed to escape to Britain during the war. However, the couple's friend, Peter Lee, persuaded Renée to have the lifeboat named after herself instead.

Peter Lee, aged ninety-three, said: 'Renée's husband was set on donating a lifeboat to the RNLI and when he passed away she wanted to carry on his will of support, hence the donation to the RNLI. Neither of them ever had any experience of the charity, they just really admired the RNLI's lifesaving work, which speaks volumes for its reputation. I wanted to persuade her to have the lifeboat named after her and I'm pleased that she agreed. I've always been a supporter of the RNLI and I think the RNLI do a fantastic job, as did Renée and her late husband.'

As soon as the new lifeboat was on station, preparations were made for her naming ceremony. However, despite much planning, the itinerary had to be changed at the last minute because heavy rain and wind meant the event had to be held inside the boathall, the doors to which were closed. B-891 was parked just outside and, at the end of the speeches and dedication, the doors were opened for the blessing and formal christening. LMG chair Mike McCartain OBE opened proceedings, and RNLI Council Member/Official Archie Smith received the boat on behalf of the RNLI from the donor's representative, Peter Lee. He in turn handed it into the care of Nick White, LOM, who formally accepted the boat on behalf of the station. The service of dedication was led by the Rev David Farrant, and the boathall doors were opened so that Peter

Mike McCartain OBE, Chairman of the Lifeboat Management Group, addresses the crowd.

Lifeboat Operations Manager Nick White addresses the assembled supporters inside the boathouse.

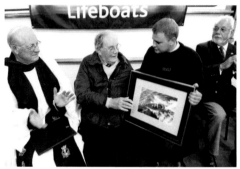

Trainee crew Adam Grummett presents a framed photo of the Atlantic 85 to the donor's representative Peter Lee.

The Rev David Farrant blesses the new Atlantic 85 at the end of the service of dedication.

Peter Lee, aged ninety-three, names the new lifeboat, with Nick White (nearest camera) looking on.

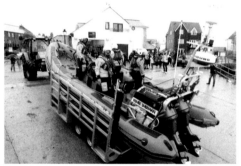

B-891 Renée Sherman is launched down the slipway at the end of her naming ceremony.

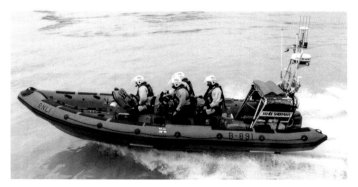

B-891 Renée Sherman is put through her paces in the river at the end of her naming ceremony. (Naming photos by courtesy of Eddie Mitchell)

B-891 Renée Sherman on exercise off Littlehampton in December 2016. (Nicholas Leach)

B-891 Renée Sherman and D-769 Ray of Hope on exercise off Littlehampton. (Nicholas Leach)

Lee could christen the boat, pouring champagne over the sponson. The Atlantic was then launched for a short demonstration within the confines of the harbour.

With the new Atlantic 85 on station, working alongside the D class inflatable, another chapter in the proud half-century history of inshore lifeboat service at Littlehampton was opened. During the years that the ILBs have been in operation, from 1967 until the end of 2016, the various lifeboats have been launched 2,454 times on service, and have saved a total of 397 lives.

William Osborne:
River Arun boatbuilder

As well as its Blue Peter lifeboats, Littlehampton was well known in lifeboat circles as a centre of lifeboat building, with the famous boatyard of William Osborne Ltd, on the banks of the river Arun, completing many lifeboats over the course of the best part of half a century. The boatyard was founded by William Osborne, who spent several years in the motor car trade, building special car bodies, before turning his attention to boating. The yard was established at Littlehampton after the First World War, and its first boat, a 40ft cabin cruiser, was launched in 1919. Tom Ashton was appointed as works director, and the firm prospered, building racing craft, motor cruisers and hydro planes.

When William Osborne died in 1931, he was succeeded as head of the firm by his son, Bill Osborne, who steadily built up the business, with Reg Chatfield, Tom Ashton's nephew, in the post of works director. Bill Osborne died on Christmas Day 1991 at the age of eighty-nine. Martin Boyce, grandson of the founder of the firm, had taken over as chairman a few years earlier and, together

The first lifeboat built by William Osborne was St Andrew (Civil Service No.10), a twin-engined 41ft Watson completed in 1952. She was stationed at Whitehills, and is pictured there during her naming ceremony on 23 August 1952. She was christened by Lady Milne, wife of Sir David Milne KCB, a Vice-Patron of the Civil Service Lifeboat Fund, which had funded the boat. (By courtesy of the RNLI)

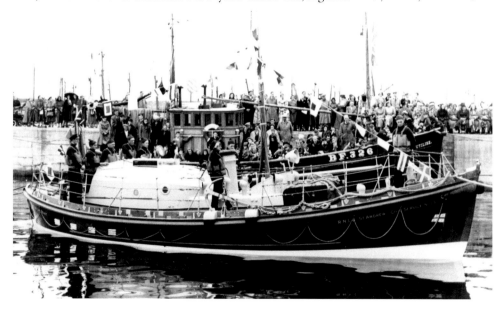

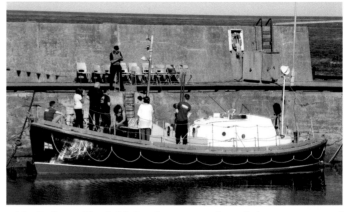

with Graham Chatfield, Reg's son as technical director, managed the firm during the 1990s.

During the Second World War, William Osborne built Fairmile motor gunboats, landing craft, storage tenders, high speed launches and a number of boats for the Thames River. After the War the firm began to build motor cruisers again, as well as luxury motor yachts, including the 81ft *Rhimea* and the 111ft *Blue Leopard*. In 1971 Osborne's produced its first glass-fibre motor cruiser and subsequently went on to develop its own range of work boats.

Osborne's yard became involved in lifeboat work in the immediate post-war years, initally undertaking a number of surveys on lifeboats. Lifeboats are surveyed and refitted periodically, with this work usually being carried out by commercial boatyards. After surveying their first lifeboat, the yard went on to overhaul and repair many lifeboats from all over the UK and Ireland.

An unusual incident took place in 1953 when the Reserve lifeboat *Thomas Markby*, which had been built in 1928 and served at Swanage for most of her career, was taken out for trials at the end of her refit. She put to sea at 9.30am on 10 November 1953 for machinery trials with a crew of four, made up of the RNLI's District Engineer, an RNLI Fleet Mechanic and two of Osborne's own employees. When two miles south-east of Littlehampton, the men saw a 26ft sailing boat drifting in the light breeze. The lifeboat went alongside to check all was well, and found three boys on board who had absconded from an Approved School. They were tired, hungry and cold, so one of the men went on board the boat, secured a tow line and the boat was towed back to Littlehampton, where the rescued boys were handed over to the police.

As well as repair and overhaul lifeboats, William Osborne became one of the RNLI's principal builders of lifeboats in the post-war years, and was involved in constructing several first-of-class lifeboats which represented notable advances in lifeboat development. The first order for a new lifeboat came in

1949, for Official Number (ON) 897, a 41ft Watson, which was launched in 1952. Named *St Andrew (Civil Service No.10)*, she was stationed first at Whitehills, in north-east Scotland, before being reallocated to Girvan and then Arklow. The next Osborne-built lifeboat was ON.907 *William Taylor of Oldham*, which was stationed at Coverack in 1954. She was the first 42ft Watson class lifeboat to be built, and was notable in being the first RNLI lifeboat to be built with commercial diesel engines.

The fourth lifeboat to be built by Osborne's was another first-of-class: the 47ft Watson ON.920 was notable in that she was the first standard lifeboat for the RNLI to be built with a wheelhouse. Previously lifeboats had been built with an open cockpit, which had subsequently been enclosed to provide a degree of crew protection. The new 47ft Watson, named *Dunnet Head (Civil Service No.31)*, was stationed at Thurso in January 1956, but unfortunately her career proved to be short as she was totally destroyed by fire in December 1956, when her boathouse also went up in flames.

Self-righting trials of a 37ft Oakley at Littlehampton. The boat, with no markings and stripped of essential equipment for the test, was turned through 180 degrees by a crane, with the water ballast transfer system bringing the boat upright after a few seconds. (By courtesy of the RNLI)

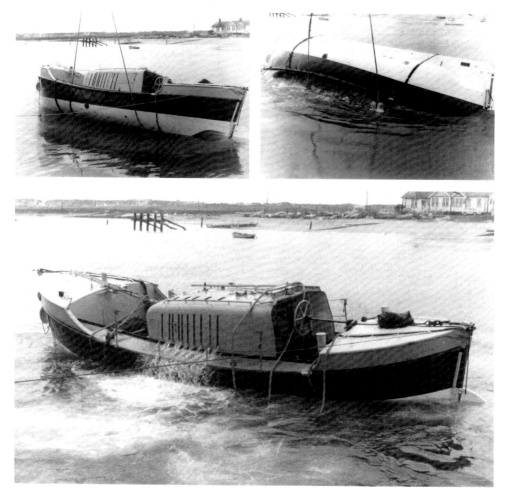

In 1958 Osborne's built the first 37ft Oakley class self-righter, ON.942 *J.G. Graves of Sheffield*. This design was notable as the first modern lifeboat which was both self-righting, achieved through a system of water ballast transfer which would right the boat in the event of a capsize, and had a high degree of lateral stability, thus representing a significant technological advance over previous designs. Osborne went on to build a number of 37ft Oakleys, and in 1963 constructed larger version of the design, 48ft in length, using the same water-ballast transfer method for self-righting. This boat, ON.968 *Earl and Countess Howe*, was another first-of-class, and was also the first RNLI lifeboat to be equipped with radar; she was stationed at Yarmouth in 1963.

In the 1970s the RNLI developed a slightly longer version of the Oakley, the 37ft 6in Rother class, and ordered the first of the new design from Osborne. This boat, ON.998 *Osman Gabriel*, was stationed at Port Erin in 1973. A total of fourteen Rothers were built between 1972 and 1982, of which twelve were completed in Littlehampton The last Rother to be built, ON.1068 *James Cable* which served at Aldeburgh, had the distinction of being the last traditional double-ended lifeboat in service in the UK and Ireland when she was replaced in 1993. The type was named after a river in East Sussex, as the RNLI had, by this time, started calling all its lifeboat classes after rivers.

At the same time as the Rother was being built, the RNLI was developing faster lifeboats and was also considering using glass

The prototype Oakley class lifeboat, ON.942 J.G. Graves of Sheffield, served at Scarborough for twenty years and had a further fifteen years in RNLI service before being retired. She was placed on display at Chatham Historic Dockyard in the 1990s, where she forms part of the Lifeboat Collection. (Nicholas Leach)

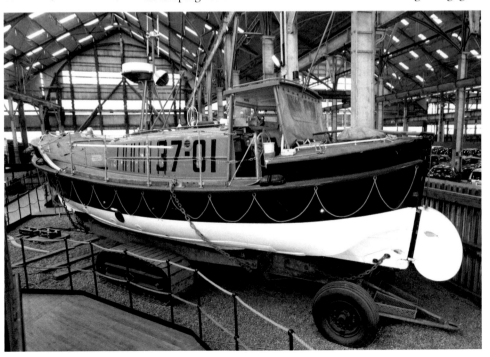

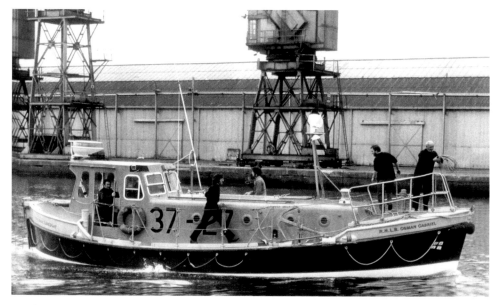

reinforced plastic (GRP) for hull construction in an effort to speed up build times and reduce costs. Osborne was heavily involved in the development of faster lifeboats, and was engaged in building the prototype of a new type of 52ft high speed self-righting lifeboat. This boat, which became the Arun class being so designated after the river at Littlehampton, was powered by twin 375hp diesel engines, which gave her a top speed of 19.95 knots, and had a semi-planing hull with an enclosed watertight wheelhouse that provided buoyancy necessary for inherent self-righting. The prototype Arun, ON.1018, was built of cold moulded Agba, and was christened *Arun* at a ceremony at Littlehampton, attended by Bill Osborne, on 23 September 1972.

The first 37ft 6in Rother class lifeboat, ON.998 Osman Gabriel, was completed by William Osborne in 1973, undertaking her self-righting trial on 8 September 1972 at Littlehampton. (By courtesy of the RNLI)

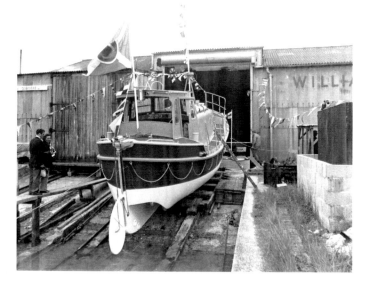

The 37ft 6in Rother ON.1047 Horace Clarkson leaving William Osborne's yard ready for her official launching and christening ceremony on 18 June 1977. (By courtesy of the RNLI)

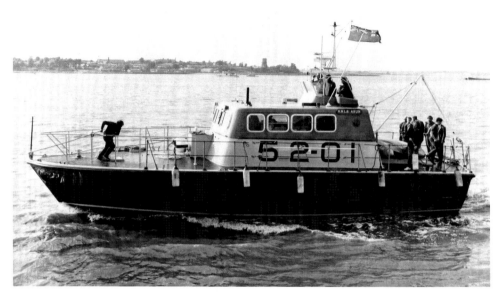

The prototype Arun class lifeboat, ON.1018 Arun, arriving at Harwich during her trials in the early 1970s. Built by William Osborne, she was a revolutionary design and went on to give good service for more than twenty years.

The Arun class lifeboat was a major advance in lifeboat design, and Osborne went on to built and fit out many boats of the class. The firm built three versions of the Arun in wood in the early 1970s, the last of which was 54ft in length due to a rounded, as opposed to square, transom. The fourth boat, ON.1049 *Tony Vandervell*, with a hull and superstructure moulded in GRP, was fitted out by Osborne. Stationed at Weymouth in 1976, she had an outstanding career, saving 359 lives over the course of more than twenty years. A total of forty-six Aruns saw service with the RNLI, of which twenty-five were either built or fitted out by Osborne, including the last of the last, ON.1160 *Duke of Atholl*, which entered the Relief Fleet in 1990.

At the same time as the Rothers and Aruns were being built, the RNLI was investigating whether small high-speed rescue boats, larger than the highly successful inflatable inshore lifeboats introduced in 1963 and offering greater capabilities, would be effective rescue craft. William Osborne was engaged in building three wooden prototypes of these boats, designated the Hatch and McLachlan types after their respective designers. The latter proved to be more successful, and in September 1969 the RNLI decided to introduce more of these 18ft 6in boats, but built in GRP rather than wood. An initial order for four McLachlans was placed with Osborne, and these boats entered service in the early 1970s. Driven by two 60hp engines, they had a top speed of over twenty knots and were crewed by three. Osborne went on to built a total of nine McLachlans between 1970 and 1975.

In the early 1980s Osborne was involved in completing several

of the RNLI's newly-developed slipway-launched lifeboat, the 47ft Tyne class. The hulls of the Tynes were built of steel by firms which specialised in steel construction, and they were then fitted out by various boatyards, which tendered for the work. In 1985 Osborne's fitted out their first Tyne, ON.1095 *St Cybi (Civil Service No.40)*, which was stationed at Holyhead, but only fitted out a further three Tynes, during the mid-1980s.

With a declared intention of operated fast lifeboats, capable of fifteen knots or more, at all stations by the early 1990s, the RNLI designed the 12m Mersey class for launching from a carriage. Again, it was Osborne who were closely involved with the development of this class, building a prototype in 1986, which never went into service, and then the first two production boats. The first, ON.1124 *Peggy and Alex Caird*, was stationed at Bridlington in 1988, and the second, ON.1125 *Sealink Endeavour*, went to Hastings in 1989. Both had aluminium hulls, but later versions of the Mersey were built from fibre-reinforced composite (FRC), and a handful of FRC Merseys were fitted out by Osborne.

Left: The hull of ON.1049 in William Osborne's yard at Littlehampton prior to being fitted out. (By courtesy of the RNLI)

Below: The hull of ON.1049, operational number 54-04, the first Arun to be constructed in glass reinforced plastic, is lowered into the river Arun at Littlehampton by crane. (By courtesy of the RNLI)

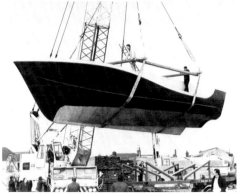

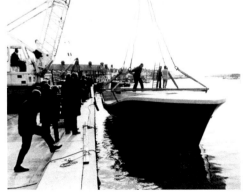

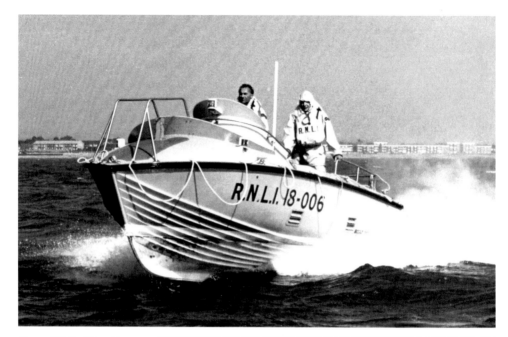

Above: 18ft 6in McLachlan lifeboat 18-006 (later number A-506) on trials off Littlehampton. William Osborne built nine of this type in the early 1970s. (By courtesy of the RNLI)

Right: The Medina rigid-inflatable was a design of offshore lifeboat developed in the early 1980s by the RNLI. However, none of the three boats of the class, all of which were built by William Osborne, entered service as the design and its propulsion system could not be proved reliable. Pictured is the prototype, ON.1069, on trials off the south coast.

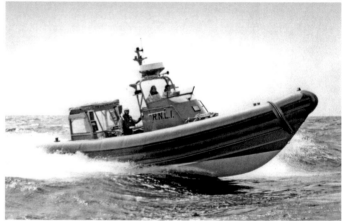

Right: The second Medina rigid-inflatable, ON.1072, being fitted with an enclosed wheelhouse at Osborne's yard in April 1984. This boat was used extensively for trials, but was sold out of service in August 1989 having never been deployed on service. (Nicholas Leach)

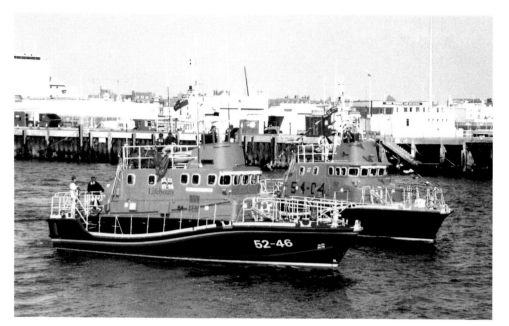

Advances in lifeboat design continued in the late 1980s and early 1990s, as the RNLI developed two designs of even faster lifeboats, capable of twenty-five knots. Known as the Severn and Trent classes, they had a hard chine hull form which incorporated propeller protection in the shape of a tunnel and bilge keels, with the hulls being moulded in FRC. The prototype of each was fitted out by Osborne, ON.1179, being the first of the 17m Severn class and ON.1180 the first of the 14m Trent class. The hulls of later boats in the classes were then moulded by Green Marine at Lymington, with fitting out undertaken at various yards along the south coast. Although no Severns were fitted out in Littlehampton, a number of Trents were completed by Osborne. Indeed, the last lifeboat to be built at Osborne was Trent ON.1240, *Sam and Ada Moody*, which went on station at Achill in April 1999.

The first GRP Arun, ON.1049 Tony Vandervell (on right), with the last 52ft Arun to be built, ON.1160 Duke of Atholl, together at Weymouth. Both were products of William Osborne.

The first 12m Mersey, ON.1124, at William Osborne's in September 1987 as just a bare aluminium hull. The hull was constructed by Aluminium Shipbuilders and brought to Littlehampton for fitting out. (Tony Denton)

The second of the two prototype 12m Merseys, ON.1125, at William Osborne's yard being fitted out, September 1987. As with the first Mersey, ON.1124, the hull was constructed by Aluminium Shipbuilders and brought to Littlehampton for fitting out. ON.1125 Sealink Endeavour was placed on station at Hastings in March 1989 after completing trials and testing. (Tony Denton)

The first 12m Mersey, Peggy and Alex Caird (ON.1124), outside Osborne's yard, October 1988. The boat was being prepared for service at Bridlington, where she was placed on station two months later. (Tony Denton)

By the late 1990s boatbuilding techniques had changed from using wood and steel to hulls made from composite materials, and William Osborne's yard did not have the facilities to handle this material, so gradually lifeboat building and repairing ceased, and this partly contributed to the eventual closure of the yard. But in its heyday Osborne's gained a fine reputation: between the 1950s and 1990s 100 offshore lifeboats were built or fitted out there, thirteen of which were first of class, and the firm's Arun shipyard, at Rope Walk, Littlehampton, became synonymous with the construction and development of lifeboats for the RNLI.

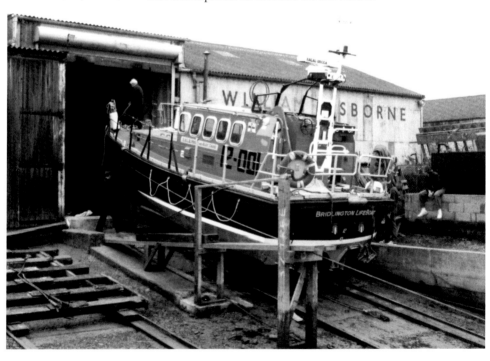

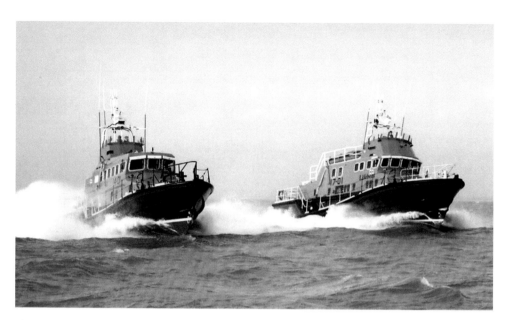

Above: The prototype twenty-five-knot lifeboats designed by the RNLI in the late 1990s, both of which were fitted out by William Osborne. On the left is ON.1180, the first 14m Trent, and on the right ON.1179, the first 17 Severn, pictured together being shown to the media off the Sussex coast.

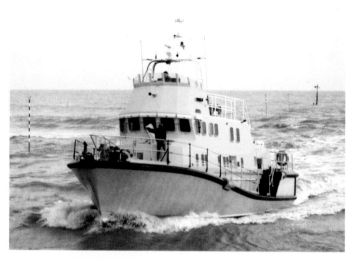

The prototype 17m Severn class lifeboat ON.1179, returns to Littlehampton during trials on 20 March 1991. (Nicholas Leach)

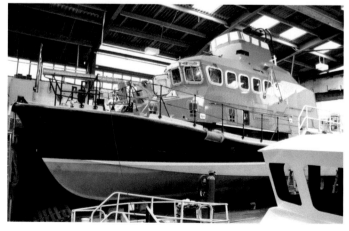

14m Trent ON.1239 Robert Hywel Jones Williams, destined for Fenit, in build at Osborne's yard, August 1998. This was the 99th and penultimate lifeboat completed in Littlehampton. (Nicholas Leach)

Lifeboats built by William Osborne Ltd

ON	Name	Length	Tyne	Stations	Disposal
897	St Andrew (Civil Service No. 10)	41ft	Watson	Whitehills 1952-59, Reserve 1959-61, Girvan 1961-68, Arklow 1968-73, Relief 1973-82	Sold 11.1982
907	William Taylor of Oldham	42ft	Watson	Coverack 1954-1972, Relief 1972-73, Arklow 1973-1986	Sold 8.1986
909	James and Barbara Aitken	42ft	Watson	Troon 1955-68, Girvan 1968-1976	Sold 4.1977
920	Dunnet Head (Civil Service No.31)	47ft	Watson	Thurso 1956-1956	Burnt in boat-house 12.1956
922	Watkin Williams	42ft	Watson	Moelfre 1956-1977, Oban 1978-1981, Relief 1981-1983	Sold 5.1983
933	J.W. Archer	42ft	Watson	Wicklow 1956-1987	Sold 3.1989
937	Mabel E. Holland	42ft	Watson	Dungeness 1957-79, Relief 1979-83	Sold 1.1983
941	William and Mary Durham	42ft	Watson	Berwick 1957-76, Girvan 1977-83	Sold 10.1983
942	J.G. Graves of Sheffield	37ft	Oakley	Scarborough 1958-78, Relief 1978-93	Displayed at Chatham
948	Charles Dibdin (Civil Service No.32)	42ft	Watson	Walmer 1959-1975, Relief 1975-1977, Eastbourne 1977-1979, Aldeburgh 1979-1982, Relief 1982-1988	Sold 10.1988
950	Kathleen Mary	47ft	Watson	Newhaven 1960-77, Porthdinllaen 1979-1987, Appledore 1987-1988	Sold 4.1990
951	Francis W. Wotherspoon of Paisley	47ft	Watson	Islay 1959-1979, Relief 1979-1982, Fishguard 1981-1982, Workington 1982-1986	Sold 10.1986
954	Solomon Browne	47ft	Watson	Penlee 1960-1981	Wrecked 12.1981
955	The Robert	47ft	Watson	Broughty Ferry 1960-75, Baltimore 1978-84, Lytham St Annes 1985-88, Beaumaris 89-91	Sold 2.1992
960	Manchester Unity of Oddfellows	37ft	Oakley	Sheringham 1961-1990	Displayed at Sheringham
968	Earl and Countess Howe	48ft 6in	Oakley	Yarmouth 1963-1976, Walton and Frinton 1977-1983	Displayed, then broken up
972	Will & Fanny Kirby	37ft	Oakley	Seaham Harbour 1963-1979, Relief 1979-1983, Flamborough 1983-1993	Sold 1993
973	Fairlight	37ft	Oakley	Hastings 1964-88, St Ives 1989-90, New Quay 1991-92, Relief 1992-93	Broken up 10.1994
974	Jane Hay	37ft	Oakley	St Abbs 1964-74, Relief 1974-1980, Newcastle (Down) 1980-1993	Broken up 1995
981	Mary Pullman	37ft	Oakley	Kirkcudbright 1965-1989	Displayed
982	Ernest Tom Nethercoat	37ft	Oakley	Wells 1965-1990, North Sunderland 1990-91	Sold 1992
983	The Doctors	37ft	Oakley	Anstruther 1965-91, Relief 1991-93	Sold 5.1993
990	Ruby and Arthur Reed	37ft	Oakley	Cromer 1967-84, St Davids 1985-88	Sold 9.1988
991	Edward and Mary Lester	37ft	Oakley	North Sunderland 1967-1989	Broken up 1989
992	Frank Penfold Marshall	37ft	Oakley	St Ives 1968-1989	Broken up 1989
993	Har-Lil	37ft	Oakley	Rhyl 1968-1990	Sold 12.1991
994	Vincent Nesfield	37ft	Oakley	Relief 1968-1991, Port Erin 1972-1973, Kilmore Quay 1988-1991	Broken up 1995
995	James Ball Ritchie	37ft	Oakley	Ramsey 1970-1991	Broken up 1992
996	Birds Eye	37ft	Oakley	New Quay 1970-1990	Displayed
997	Lady Murphy	37ft	Oakley	Kilmore Quay 1972-1988	Broken up 1995

ON	Name	Length	Tyne	Stations	Disposal
998	Osman Gabriel	37ft 6in	Rother	Port Erin 1973-1992	
999	Diana White	37ft 6in	Rother	Sennen Cove 1973-1991	Sold 1992
1000	Mary Gabriel	37ft 6in	Rother	Hoylake 1974-1990, Rhyl 1990-1992	Sold 10.1992
1015	Charles Henry	48'6	Oakley	Selsey 1969-1983, Baltimore 1984-87	Sold 1987
1016	Princess Marina	48'6	Oakley	Wick 1970-1988	Broken up 2004
1018	Arun	52ft	Arun	St Peter Port 1972-73, Barry Dock 1974-1997	Sold 10.1997
1024	The Hampshire Rose	37ft 6in	Rother	Walmer 1975-1990, Relief 1990-92	Sold 10.1992
1025	Sir William Arnold	52ft	Arun	St Peter Port 1974-1997	Sold 2.1998
1037	Edward Bridges (Post Office and Civil Service No.37)	54ft	Arun	Torbay 1975-1994	Displayed at Chatham
1046	Silver Jubilee (C.S.No.38)	37ft 6in	Rother	Margate 1978-1991, Relief 1991-93	Sold 3.1994
1047	Horace Clarkson	37ft 6in	Rother	Moelfre 1977-1986, Relief 1986-93	Sold 5.1993
1048	Alice Upjohn	37ft 6in	Rother	Dungeness 1977-92, Relief 1992-93	Sold 1995
1049	Tony Vandervell	54ft	Arun	Weymouth 1976-99	Sold 5.1999
1051	The Gough-Ritchie	54ft	Arun	Port St Mary 1976-98	Sold 7.1998
1053	Joy and John Wade	52ft	Arun	Yarmouth 1977-2001	Sold 6.2002
1054	Shoreline	37ft 6in	Rother	Blyth 1979-1982, Arbroath 1982-93	Sold 2.1994
1055	The Duke of Kent	37ft 6in	Rother	Eastbourne 1979-1993	Sold 7.1995
1057	Soldian	52ft	Arun	Lerwick 1978-97, Relief 1997-98, Achill 1998-99, Relief 1999-2002	Sold 3.2002
1058	Elizabeth Ann	52ft	Arun	Falmouth 1979-97, Relief 1997-2002	Sold 6.2002
1061	George and Olive Turner	52ft	Arun	Tynemouth 1980-99, Relief 1999-2000	Sold 8.2000
1063	Princess of Wales	37ft 6in	Rother	Barmouth 1982-1992	Sold 5.1993
1064	The Davys Family	37ft 6in	Rother	Shoreham Harbour 1982-1986, Relief 1986-1993	Sold 7.1995

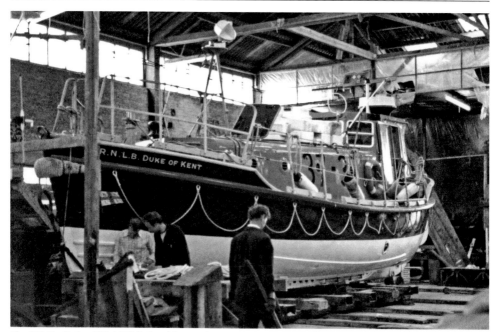

The 37ft 6in Rother ON.1055 Duke of Kent undergoing maintenance work in July 1983; she was built at the yard during 1978-79 and served at Eastbourne from 1979 to 1993. (Tony Denton)

ON	Name	Length	Tyne	Stations	Disposal
1067	Hyman Winstone	52ft	Arun	Holyhead 1980-1983, Ballycotton 1985-1998, Larne 1998-2000, Relief 2000-02	Sold 4.2003
1068	James Cable	37ft 6in	Rother	Aldeburgh 1982-1993	Sold 5.1994
1070	Richard Evans (C.S. No.39)	52ft	Arun	Portrush 1981-2000, Relief 2000-03	Sold 7.2003
1073	Robert Edgar	52ft	Arun	St Mary's 1981-97, Relief 1997-99, Weymouth 1999-2002	Sold 2.2003
1077	Duchess of Kent	52ft	Arun	Relief 1982-2002	Sold 4.2003
1078	Davina and Charles Hunter Matthews	52ft	Arun	Mallaig 1981-2001, Relief 2001-03	Sold 7.2003
1082	Margaret Frances Love	52ft	Arun	Valentia 1982-1996, Barry Dock 1997-2003	Sold 7.2005
1086	A.J.R. and L.G. Uridge	52ft	Arun	Relief 1983-2003	Sold 8.2003
1091	[Un-named]	39ft	Medina	Trials 1983-89	Sold 4.1989
1092	St Brendan	52ft	Arun	Rosslare Harbour 1984-2001	Sold 2.2003
1093	Charles Brown	52ft	Arun	Buckie 1984-2003, Relief 2003-05	Sold 11.2005
1095	St Cybi (Civil Service No.40)	47ft	Tyne	Holyhead 1985-97, Relief 1997-2007	Sold 2007
1099	Joseph Rothwell Sykes and Hilda M	52ft	Arun	Stromness 1984-98, Broughty Ferry 1999-2001, Relief 2001-02	Sold 2002
1106	Keith Anderson	52ft	Arun	Newhaven 1985-99, Relief 1999-2000, Hartlepool 2000-03	Sold 1.2006
1107	City of Belfast	52ft	Arun	Donaghadee 1985-2003, Relief 2003	Sold 11.2005
1112	RFA Sir Galahad	47ft	Tyne	Tenby 1986-2006, Relief 2006-08, Angle 2008-09	Sold 1.2010
1114	The Lady Rank	47ft	Tyne	Angle 1987-2008, Relief 2008-11	Sold 7.2011
1115	Good Shepherd	47ft	Tyne	Relief 1987-2010	Sold 6.2010
1118	Roy and Barbara Harding	52ft	Arun	Aran Islands 1987-97, Castletownbere 1998-2004	Sold 6.2004

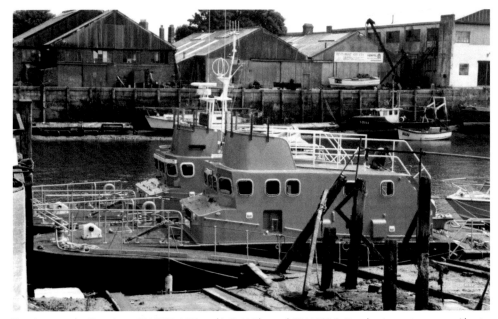

Two Aruns on the River Arun: ON.1086 A.J.R. and L.G. Uridge and ON.1092 St Brendan (nearest camera, without markings) moored outside Osborne's yard on 15 July 1983. (Tony Denton)

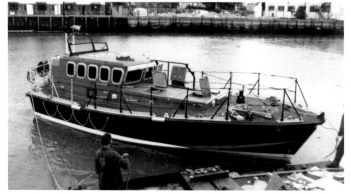

Self-righting trials for 12m Mersey ON.1185 Moira Barrie in the River Arun on 5 May 1992. Most lifeboats underwent a self-righting trial, which involved them being turned upside down by a crane, with the boat righting once the crane strop had been released in about six seconds. Moira Barrie was one of eight Merseys built in Littlehampton, and she was placed on station at Bamouth on 7 October 1992. (Tony Denton)

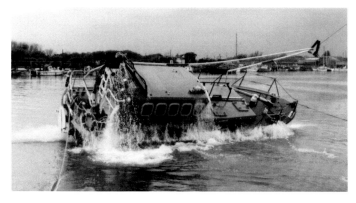

ON	Name	Length	Tyne	Stations	Disposal
1119	[Un-named]	12m	Mersey	Trials 1986-87	Sold 12.1989
1124	Peggy and Alex Caird	12m	Mersey	Bridlington 1988-1995, Relief 1995-2009, Bembridge 2009-10, Relief 2010-15	Sold 7.2015
1125	Sealink Endeavour	12m	Mersey	Hastings 1989-	In service
1149	The Queen Mother	52ft	Arun	Thurso 1989-2004, Longhope 2004-06, Relief 2006-09	Sold 2009
1150	Hibernia	52ft	Arun	Relief 1989-2007	Sold 2007
1160	Duke of Atholl	52ft	Arun	Relief 1990-2007	Sold 12.2013
1165	Spirit of Derbyshire	12m	Mersey	Ilfracombe 1990-2015	Sold 10.2015
1167	Princess Royal (C.S.No. 41)	12m	Mersey	St Ives 1990-2015; Relief 2015-16	Sold 2016
1179	Maurice and Joyce Hardy	17m	Severn	Trials 1991-98; Training 1998-2004	Sold 2004
1180	Earl and Countess Mountbatten	14m	Trent	Alderney 1994-1995, Relief 1995-	In service
1185	Moira Barrie	12m	Mersey	Barmouth 1992-	In service
1187	Mary Margaret	12m	Mersey	Kilmore Quay 1992-	In service
1190	Doris Bleasdale	12m	Mersey	Clogher Head 1993-	In service
1195	Royal Thames	12m	Mersey	Eastbourne 1993-2012, Leverburgh 2012-	In service
1197	Esme Anderson	14m	Trent	Ramsgate 1994-	In service
1199	Roy Barker I	14m	Trent	Alderney 1994-	In service
1205	Frederick Storey Cockburn	14m	Trent	Courtmacsherry Harbour 1995-	In service
1207	Sir Ronald Pechell Bt	14m	Trent	Dunbar 1996-2008	Broke moorings and wrecked, 23.3.2008
1209	Barclaycard Crusader	14m	Trent	Eyemouth 1996-	In service
1211	George and Ivy Svanson	14m	Trent	Sheerness 1996-	In service
1213	Henry Heys Duckworth	14m	Trent	Relief 1996-	In service
1215	Elizabeth and Ronald	14m	Trent	Dunmore East 1996-	In service
1223	Ger Tigchelaar	14m	Trent	Arklow 1997-	In service
1225	Macquarie	14m	Trent	Sunderland 1997-	In service
1227	Mora Edith Macdonald	14m	Trent	Oban 1997-	In service
1233	Austin Lidbury	14m	Trent	Ballycotton 1998-	In service
1234	Gough-Ritchie II	14m	Trent	Port St Mary 1998-	In service
1239	Robert Hywel Jones Williams	14m	Trent	Fenit 1999-	In service
1240	Sam and Ada Moody	14m	Trent	Achill 1999-	In service

As well as building offshore lifeboats, Osborne's yard also built a number of ILBs, including several rigid-hulled McLachlans. A-504, which served at Weston-super-Mare from 1970 to 1983, is pictured there manned by Nick White (on right) who later served on the crew at Littlehampton, and went on to became LOM. (By courtesy of Nick White)

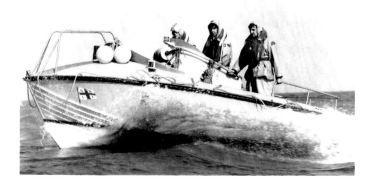

14m Trent ON.1240 Sam and Ada Moody, the last lifeboat completed by William Osborne, on station at Achill on Ireland's west coast, where she operates from what is one of the most picturesque locations for any lifeboat station in the UK and Ireland. (Nicholas Leach)

Appendices

A • Pulling and sailing lifeboat era 1884-1921

Lifeboats

Years on station (launches/saved)	Dimensions Type	Cost ON	Year built Builder	Name Donor
8.1884 – 1888 (2/0)	32' x 7'5" SR, 10 oars	£210 —	1865 Forrestt, Limehouse	*Undaunted* Gift of Mr & Mrs R. West, Streatham Hill
5.1888 – 7.1904 (10/12)	34' x 7'6" SR, 10 oars	£329 172	1888 Woolfe, Shadwell	*James, Mercer and Elizabeth* Gift of Mrs Stoker, Hull
7.1904 – 12.1921 (14/10)	35' x 8'6" SR, 10 oars	£800 531	1904 Thames IW, Blackwall	*Brothers Freeman* Legacy of Francis J. Freeman, London

Services

James, Mercer and Elizabeth Lifeboat

1892	Aug 14	Yawl *Surf*, of Littlehampton, saved yawl and 2
1894	Jan 11	Brigantine *C.H.S.*, of Llanelli, saved 4
1901	Nov 12	Brigantine *Amy*, of Plymouth, saved 6
1903	Feb 26	Steamship *Brattingsborg*, of Copenhagen, stood by

Brothers Freeman Lifeboat

| 1908 | Oct 19 | Motor yacht *Swallow*, of Newhaven, saved yacht and 1 |
| 1912 | Aug 6 | Barque *Anirac*, of Genoa, saved 9 |

Personnel

Honorary Secretaries

Ch Offr W Gould, CG	1894-1897
H.C. Barrett	1897-1905
Ralph Moon	1905-1907
Thomas Symes	1907-2.1919
F.W. Griffiths	1919-1921

Coxswains

Charles Pelham	1884-1897
Alexander Pengilly	7.1897-12.1907
George John Pelham	1.1908-10.1918

After 1918 no Coxswain was officially appointed; the former Second Coxswain, Alonzo Allen, served as Acting Coxswain until he retired on 10 January 1919 owing to ill health.

Second Coxswains

Alexander Pengilly	1885-1897
George John Pelham	7.1897-12.1907
Alonzo Walter Allen	1.1908-10.1.1919

B • Inshore lifeboat summary

Years on station (launches/saved)	ON	Name (if any) Donor	Type Notes
1967 – 1972	D-115	*Blue Peter I* Blue Peter Television Appeal.	15'6" RFD PB16
28.6.1972 – 7.1973	B-504	— —	Atlantic 21
1.7.1973 – 11.1974	B-517	*Blue Peter I* Blue Peter Television Appeal.	Atlantic 21
22.11.1974 – 5.1985	B-523	*Blue Peter I* Blue Peter TV Appeal, and Littlehampton Rotary Club.	Atlantic 21
7.9.1985 – 2.2001	B-564	*Blue Peter I* Blue Peter Television 1984–85 Winter Appeal.	Atlantic 21
24.2.2001 – 20.8.2002	B-586	*Clothworker* Clothworker's Foundation.	Atlantic 21
20.6.2002 – 5.2016	B-779	*Blue Peter I* Pieces or Eight Appeal 1993.	Atlantic 75
19.5.2016 –	B-891	*Renée Sherman* Legacy of Renée Sherman, of Wiltshire.	Atlantic 85
20.6.2002 – 2003	D-433	*Marjorie* Bequest of Roger Newton May.	16'3" Avon EA16
2003 – 2004	D-431	*Veronica* Bequest of Miss Doris Veronica Tudor-Williams.	16'3" Avon EA16
10.2004 – 7.7.2014	D-631	*Spirit of Juniper* Fundraising by the Campaign for Real Gin.	IB1
7.7.2014 –	D-769	*Ray of Hope* Gift of Ray and Val Humby.	IB1

1967-71: operational summer only 1971-72: all year round, daylight only
1972 on: operational twenty-four hours a day, all year round

Date/ILB	Services	
1970	**35**	**17**
D-115	35	17
1971	**35**	**16**
D-115	35	16
1972	**39**	**11**
B-500	3	3
B-504	25	7
D-115	11	1
1973	**48**	**18**
B-504	22	1
B-517	26	17
1974	**33**	**14**
B-503	1	0
B-511	7	3
B-517	22	11
B-523	3	0
1975	**45**	**18**
B-523	38	15
B-526	7	3
1976	**42**	**2**
B-523	26	2
B-526	4	0
B-541	12	0
1977	**41**	**1**
B-523	41	1
1978	25	1
B-523	25	1
1979	**39**	**11**
B-523	4	1
B-542	35	10
1980	**27**	**13**
B-523	27	13
1981	**33**	**9**
B-523	33	9
1982	**34**	**9**
B-512	1	0
B-523	33	9
1983	**78**	**27**
B-512	76	27
B-523	2	0

Date/ILB	Services	
1984	**44**	**11**
B-511	3	1
B-523	41	10
1985	**39**	**11**
B-523	35	11
B-564	4	0
1986	**52**	**18**
B-518	8	0
B-564	44	18
1987	**46**	**21**
B-564	46	21
1988	**39**	**16**
B-515	1	0
B-564	38	16
1989	**45**	**20**
B-511	3	0
B-564	42	20
1990	**39**	**19**
B-511	12	5
B-564	27	14
1991	**29**	**10**
B-527	12	5
B-564	17	5
1992	**46**	**11**
B-527	1	0
B-564	45	11
1993	**37**	**9**
B-539	4	5
B-564	33	4
1994	**58**	**7**
B-535	42	6
B-564	16	1
1995	**49**	**1**
B-564	49	1
1996	**57**	**8**
B-527	4	0
B-564	46	4
B-569	7	4
1997	**51**	**13**
B-514	11	0
B-564	40	13

Date/ILB	Services	
1998	**37**	**10**
B-515	6	2
B-531	1	0
B-564	30	8
1999	**34**	**7**
B-514	8	5
B-515	1	0
B-564	25	2
2000	**33**	**6**
B-564	33	6
2001	**53**	**5**
B-564	1	0
B-586	52	5
2002	**37**	**1**
B-586	12	1
B-779	22	0
D-433	3	0
2003	**63**	**1**
B-755	1	0
B-779	39	1
D-431	4	0
D-433	19	0
2004	**78**	**3**
B-779	56	3
D-431	9	0
D-441	1	0
D-458	11	0
D-631	1	0
2005	**81**	**0**
B-779	44	0
D-602	7	0
D-631	30	0
2006	**49**	**0**
B-779	29	0
B-792	4	0
D-602	4	0
D-631	12	0
2007	**75**	**0**
B-779	49	0
D-631	22	0
D-680	4	0

Date/ILB	Services	
2008	**84**	**0**
B-773	22	0
B-779	28	0
D-631	31	0
D-635	2	0
D-680	1	0
2009	**109**	**3**
B-779	68	3
D-603	6	0
D-631	28	0
D-640	1	0
D-710	6	0
2010	**95**	**0**
B-774	5	0
B-779	58	0
D-631	27	0
D-640	5	0
2011	**78**	**3**
B-779	50	3
D-631	24	0
D-640	4	0
2012	**63**	**0**
B-779	40	0
D-631	18	0
D-715	5	0
2013	**55**	**3**
B-779	37	3
D-631	18	0
2014	**70**	**0**
B-773	25	0
B-779	20	0
D-631	9	0
D-769	15	0
2015	**68**	**1**
B-779	50	1
D-631	1	0
D-769	17	0
2016	**54**	**0**
B-779	9	0
B-891	27	0
D-769	18	0

The numbers indicate launches (column two) and lives svaed (column three). The figures for each year are the totals, with the ILBs which were on station during that year listed beneath.

D • Honorary Secretaries and Operations Managers

Peter Cheney (1967-1993)

Peter Cheney became the station's first Honorary Secretary and was tasked with setting up the station when talks started in 1966. He was a man of standing and great warmth, and remained the station's Secretary for twenty-five years after which he became the station's chairman. He remained involved with the lifeboat until his health was in decline, and he died in January 2014.

Paul Naish (1993–1998)

Paul Naish, then the harbour master at Littlehampton, took over from Peter Cheney in 1993. He relinquished the post when he moved to become manager of the ferry terminal at Portsmouth International Port in 1998.

John Jones (1998-2008)

John Jones remained involve with the station well into his seventies, having initialy worked on lifeboats at Osborne's yard, where he was one of the staff coxswains, before becoming Honorary Secretary, and he light-heartedly claimed to have been the longest serving Acting Honorary Secretary, as he was considered to be only 'acting'. His period in charge straddled the time when the post's title changed to Lifeboat Operations Manager.

Nick White (2008 on)

Nick White originally volunteered on Weston-super-Mare lifeboat in the 1970s. He moved to Sussex in the late 1980s, transferred to Littlehampton and served as a helm untill 1996. After an eight-year break from the RNLI, he returned in 2004 as DLA. He was accorded the Thanks on Vellum for a rescue in 1978, and the Ralph Glister Award for the same service. He was also awarded a Vellum Service Certificate in 1986, and later a long service badge.

E • Littlehampton lifeboat volunteers 2017

Fund-raisers • Back row, left to right: Mike Greenland (Event Co-ordinator and Fundraising Committee Member), Steve Burvill (Honorary Lifetime Fundraising Committee Member), Colin Cates (Fundraising Volunteer and Education and Visits), Tom Drennan (Education and visits), Ian Shaw (Fundraising Committee Member), John Holden (Fundraising Committee Member), Malcolm Somner (Fundraising Committee Chairman), Keith Burrell (education and visits), Brian Capp (shop volunteer and education and visits), Tony Carter (shop volunteer); front row, left to right: Maurice Dibble (shop volunteer and Fundraising Committee Member), Monica Dibble (shop volunteer and Fundraising Committee Member), Rod Oliphant-Callum (education and visits), Graham Paull (Fundraising Treasurer and Committee Member), Angela Shaw (Shop Volunteer), Bill Beason (Shop Volunteer and education and visits), John Phipps (education and visits), David Dawson (Shop Volunteer and education and visits).

Shop and visits • Back row, left to right: Steve Burvill (Honorary Lifetime Fundraising Committee Member), Monica Dibble (Shop Volunteer and Fundraising Committee Member), Mike Greenland (Event Co-ordinator and Fundraising Committee Member), John Holden (Fundraising Committee Member), Malcolm Somner (Littlehampton Fundraising Committee Chairman), Maurice Dibble (Shop Volunteer and Fundraising Committee Member); front row, left to right: Ian Shaw (Fundraising Committee Member), Thelma Flack (Shop Volunteer Manager), Colin Cates (Fundraising Volunteer and Education & Visits), Rod Oliphant-Callum (Education & Visits), Graham Paull (Fundraising Treasurer and Committee Member), Ian Flack (Shop Volunteer Manager)

Retired crew from the early years of the inshore lifeboat • John Pelham (on right) is the sole survivor from the original 1967 crew, while Ray Lee (seated centre) and Dave Woollven (seated left) joined a couple of years after the station reopened.

John worked at Osborne's building, fitting out and maintaining RNLI lifeboats, and both his grandfather and great-grandfather were coxswains during the pulling and sailing era. Ray was a dive boat skipper, operating his own boat out of Littlehampton. Dave was on the crew for many years, being awarded a long service badge and accorded the Thanks of the Institution on Vellum.

Mike McCartain OBE (standing) joined the crew as a teenager,

leaving when he joined the Royal Navy to serve a long commission, during which he commanded several ships. In civilian life, he was part of the senior management of Cunard and P&O, and later Associated British Ports. He returned to Littlehampton RNLI in 2014, becoming chairman of the lifeboat management group.

Long serving crew members

Andy Harris (left), helm and mechanic, joined the crew in 1996, and was awarded a long service badge in 2016. He is a builder and charter boat owner. Ritchie Southerton (centre), helm and deputy lifeboat training coordinator, joined the in 1997 and was full-time RNLI crew on the Thames. Ivan Greer (right), helm and mechanic, joined in 1991, and was awarded a long service badge in 2011. He is a workboat coxswain.

The stalwart

Geoff Warminger joined the crew in 1972 and served for twenty years until he reached the retirement age, receiving his long service badge. He served as deputy launching authority for a further twenty years, for which he was awarded the RNLI's Gold Badge. He is now the boathouse manager and expects everything to shine, hence being dubbed 'queen of clean' by some of the crew.

Littlehampton lifeboat crew 2017

Overleaf: on boat, left to right: Adam Grummett, Richard Howlett (both trainee crew), Ritchie Southerton (helm), Hannah Presgrave (trainee crew), and Matt Brewster (shore crew); standing, left to right: Liam Clarke, Jim Cosgrove, Warren Marden (all crew), Ivan Greer, Andy Harris (both helms and station mechanics), Steve Howlett (trainee crew), Ian Foden (crew), Alice White, Min Morgan (both shore crew), Nick White (LOM), Adam Harding (shore crew), Geoff Warminger (boathouse manager), Ray Pye (lifeboat press officer) and David Gates (DLA).

LIFEBOAT PERSONNEL 2017

MANAGEMENT • Lady Herries (President); Mike McCartain (LMG Chairman); Nick White (Lifeboat Operations Manager); David Gates; Peter Knight; Billy Johnson; Tim Millward and Ivan Warren (all Deputy Launching Authorities); Lisa Rogers-Davis (Lifeboat Administration Officer); Bill Montague (Lifeboat Treasurer); Gordon Byars (Lifeboat Medical Advisor); Ray Pye (Lifeboat Press Officer); Eddie Mitchell (Press); Sandra Anderson (Education & Visits Co-ordinator); Bill Beason; David Dawson and Geoff Warminger (all Boathouse Managers).

CREW • Tom Bezants, Martin Blaker, Keith Booth, Ross Bowman, Liam Clarke, Olly Clarke, Oliver Cona, Jim Cosgrove, Lee Cullen, Rob Devo, Ian Foden, Ivan Greer, Josh Gruber, Andy Harris, Lee Harrison, Andy Hicks, Warren Marden, Laura Robinson, Gavin Simmons, Ritchie Southerton, Simon Tann, Richard Winstanley.

TRAINEE CREW • Adam Grummett, Richard Howlett, Steve Howlett, Hannah Presgrave.

SHORE CREW • Matt Brewster, Adam Harding, Sam Hubbard, Min Morgan, Jodi Randall, Alice White, Adam Willcocks.

PAST PERSONNEL

MANAGEMENT • Peter Cheney (Hon Sec & Chairman), Paul Naish Hon Sec and DLA), John Jones (Hon Sec/LOM and DLA), Steve Strickland (Lifeboat Treasurer), George Barnes DLA, Lee Hamilton-Street DLA, George Moore DLA, Jim Petty DLA, Len Pope DLA, Chris Shanks DLA, Geoff Warminger DLA, Ian Woollard DLA.

CREW • Lois Anderson, George Barnes, Mike Bentley, Mick Booker, Chris Booth, Scott Bowman, Mark Clothier, Terry Cobden, Roy Cole, Michael Coombes, Jenny Cradock, Howard Crompton, Richard Dixon, Steve Edwards, Gareth Flower, Rob Forster, Angela Gates, Oliver Griffiths, Lee Hamilton-Street, Paul Harrington, Fred Hill, David Hobden, Peter Holliday, Keith Hopper, Chris Johnson, Peter Knight, Ray Lee, Dane Leekam, Jon Maidment, David Martin, Terry Matthews, Mike McCartain, Nick Miller, George Moore, Gordon Muir, Colin Munro, Jerry Norris, Jim Osborn, John Pelham, Brian Pelham, Andy Peace, Mick Perry, Jack Pidcock, Bill Porter, Jim Raven, AD Richardson, Peter Robinson, Rob Rollins, Kevin Seberry, Colin Seberry, Chris Shanks, Andrew Sleeman, Jon Street, Iain Tebb, Steve Tester, Les Towse, Bob Tuffnell, Dennis Vinehill, Kevin Warminger, Geoff Warminger, Brian White, Nick White, Tom White, Faye White-Sharman, Terry Wicks, David Woollven, Michael Woollven.

SHORE CREW • Tim Clarke, Kingsley Cunningham, Stan Doe, Ken Greer, Michelle Greer, Nikki Hamilton-Street, Peter Nock.